a fool moon...

more art of Will Bullas

INTRODUCTION BY DORIS DAY

THE GREENWICH WORKSHOP PRESS

Introduction . . .

Many of my closest friends have four legs. They come in all colors, shapes and sizes and speak many different languages. I enjoy their varied personalities, all individual and often quite like humans. For years I have been an ardent lover and protector of animals and am always happy to meet others who share this understanding.

Several years ago, I became familiar with the work of an artist who captures the appeal and personality of animals in a most delightful manner. He is an excellent artist with an uncanny sense of the nature of animals, along with the ability to express those feelings with touching realism. To these talents he adds his finely honed sense of humor and clever wordplay to create very special works of art.

Will Bullas has been making animal lovers chuckle for over twenty years. Ever since that first painting of one of his endearing Indian Runner ducks, Will has been

spreading smiles by creating paintings that show animals in various settings, attire or situations to which we humans can relate. We learn a lot about the natural world

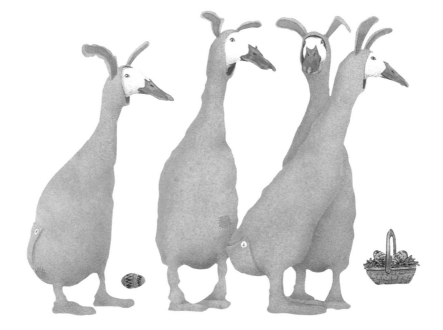

from animals and a lot about ourselves along the way.

My own personal favorite Bullas paintings are *Nerd Dogs*, *Dog Byte*, *Puppy Glove* and *That's What Friends Are For*.

I invite you to enjoy the paintings presented on these pages and to love and care for their real-life counterparts.

—Doris Day

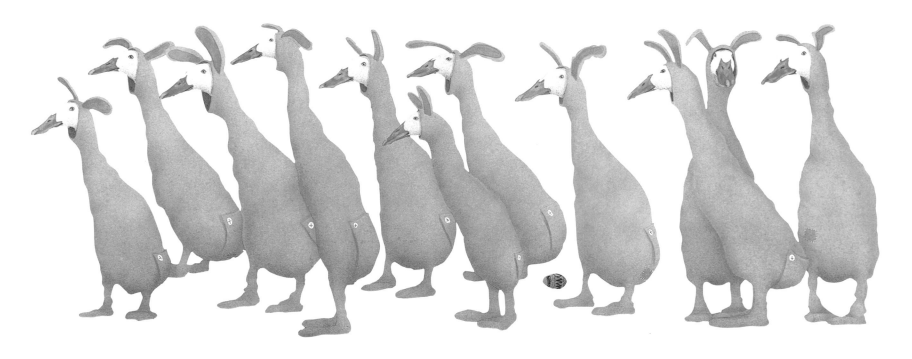

A GREENWICH WORKSHOP PRESS BOOK

Inquiries should be addressed to The Greenwich Workshop, Inc.,
One Greenwich Place, P.O. Box 875, Shelton, Connecticut 06484-0875.
Distributed to the trade by Artisan, a division of Workman Publishing, 708 Broadway, New York, NY 10003

•

Library of Congress Cataloging-in-Publication Data:
Bullas, Will, 1949–
A fool moon— : more art of Will Bullas / introduction by Doris Day. p. cm.
ISBN 0-86713-052-0 (pbk. : alk. paper)
1. Bullas, Will, 1949– —Humor. 2. Animals in art. I. Title.
ND1839.B77A4 1998 759. 13—dc21 98-22458 CIP

•

Contributing editor: Jennifer Hill
Book design by Judy Turziano
Manufactured in China by Toppan
98 99 00 01 0 1 2 3 4 5 6 7 8 9

I love a charade . . .

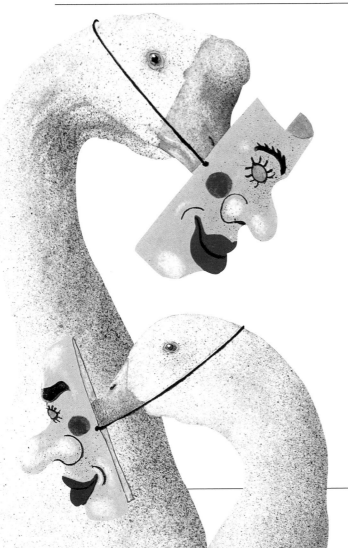

Here's the parlor-room guessing game at its fine-art funniest. Whether they're in disguise or in a charade, Will Bullas' creatures pantomime their alter-ego wannabes. They're funny because we recognize them all. Everyone needs a little *Tom Foolery* now and again.

How did you feel the last time you were cajoled into *A Visit with the In-Laws?* Bet you were faking all that conformity. . . still, *What's a Pirate to Do?* Your secret's out, though, because your kid is *A Chick off the Old Block.*

Will Bullas splashes in an undercurrent behind the scenes where sometimes he plays with our cherished notions and other times he just plays. The next time you see an ape with a wig, you'll know you're in the *Court of Appeals,* where all that stuffy British protocol makes even the *Lards of London* wish they were *Haunted Hams.*

Will Bullas is an equal-opportunity humorist. You haven't seen *Duck Tails* until you've seen them in the hands of the duckmeister. Nobody gets off clean. Even *Granny Gets a Goose.*

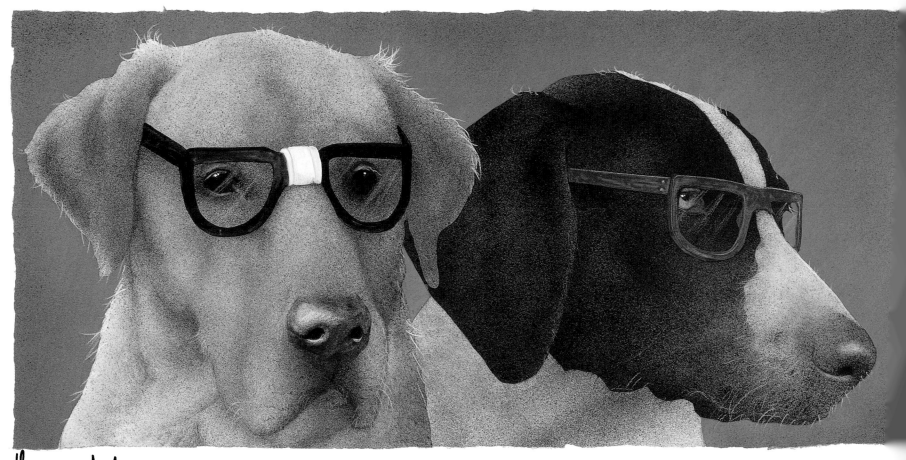

the nerd dogs . . .

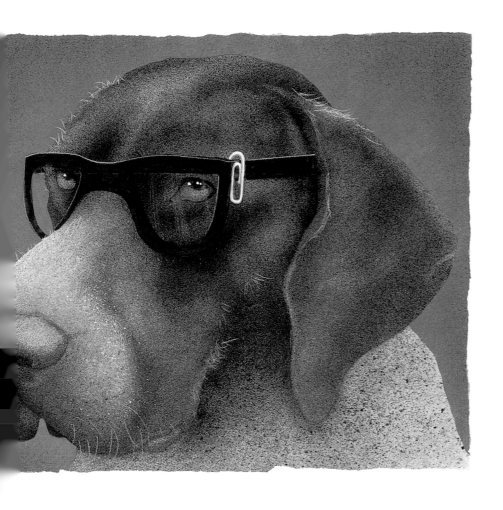

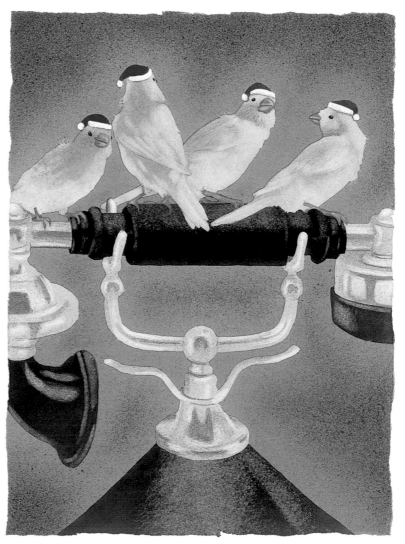

four calling birds . . .

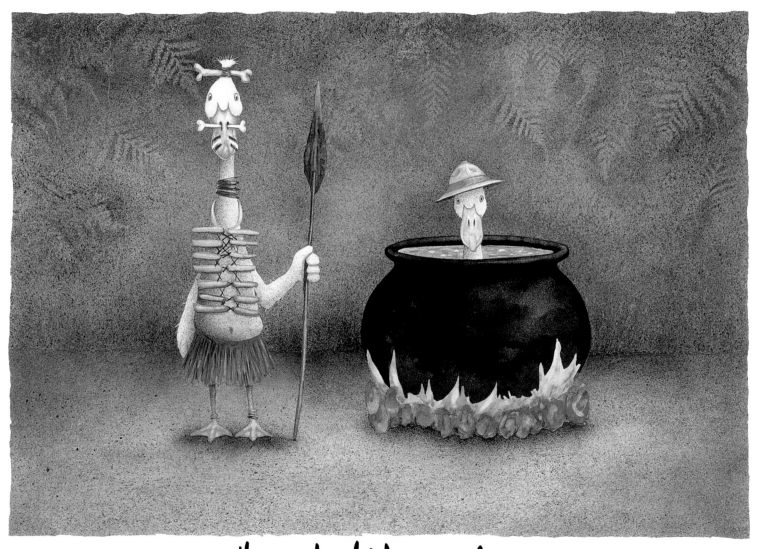

the early bird-special...

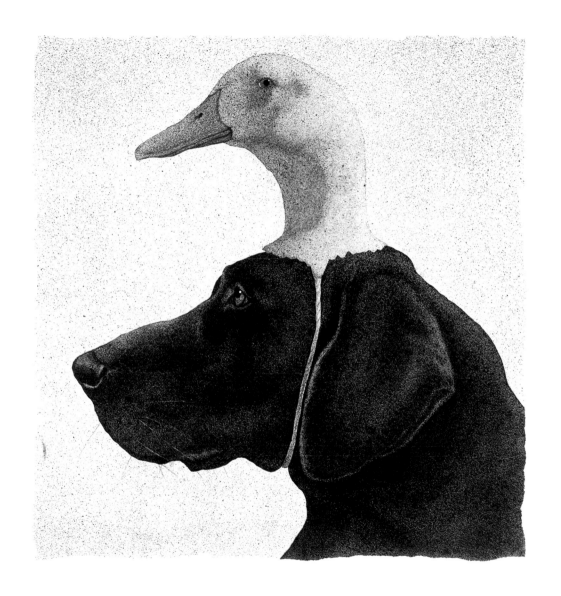

the reluctant
retriever...

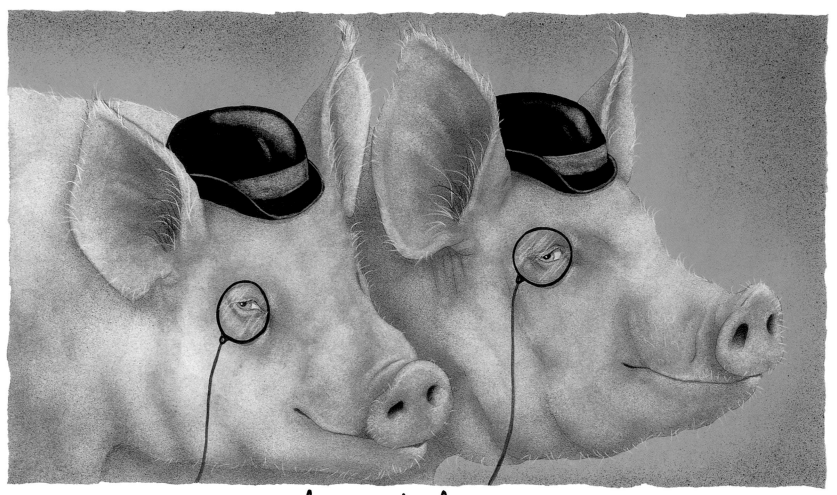

lards of London...

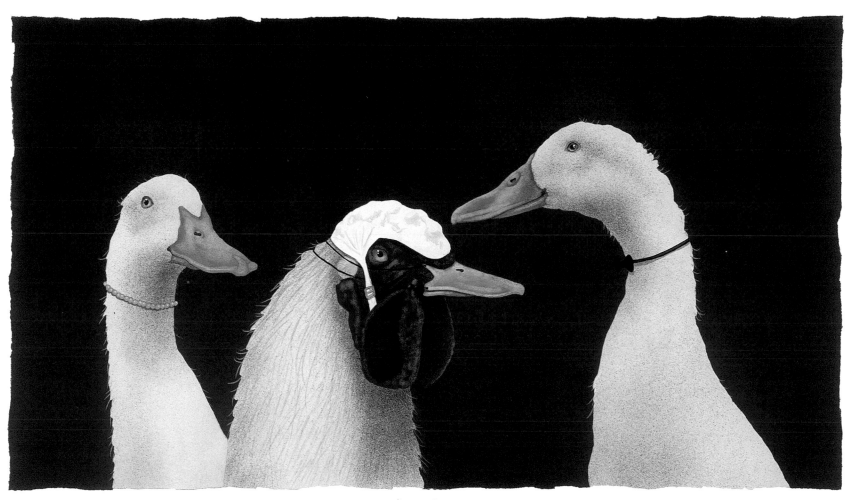

a visit with the in-laws...

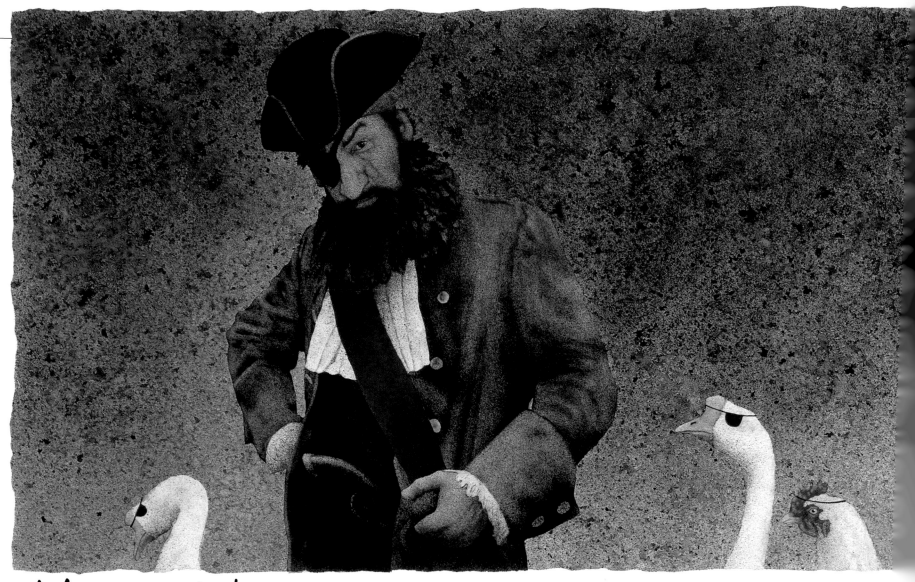

what's a pirate to do...

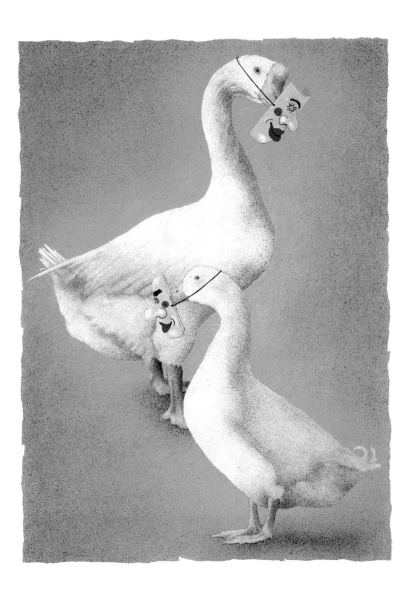

I love a
charade ...

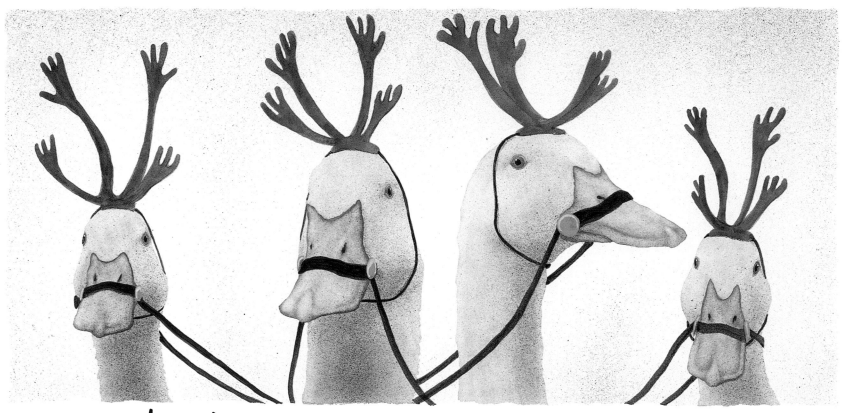

this Christmas was going to be different....

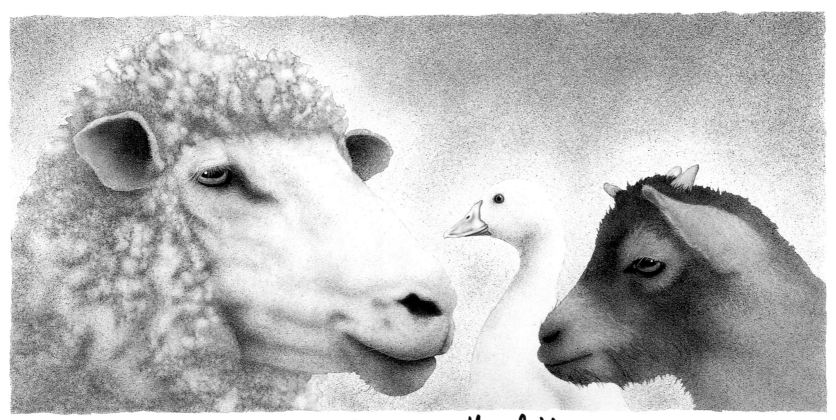

ewe and me and the kid . . .

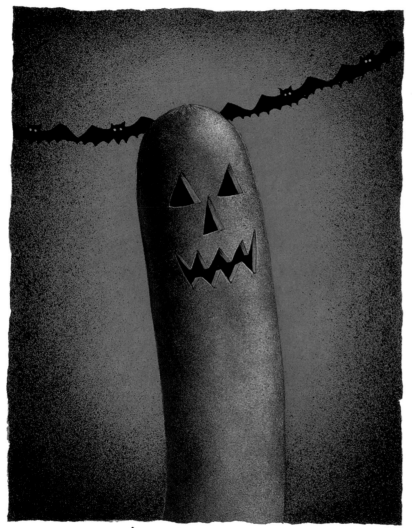

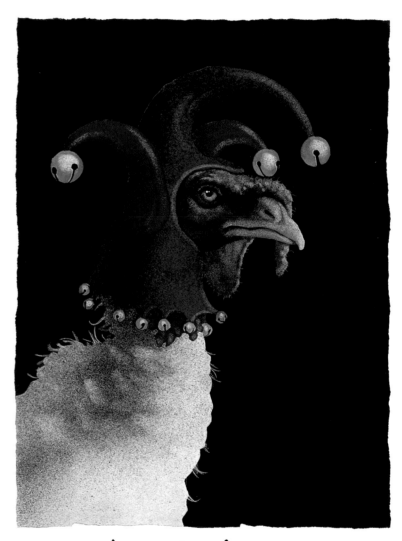

Halloweenie... tom foolery...

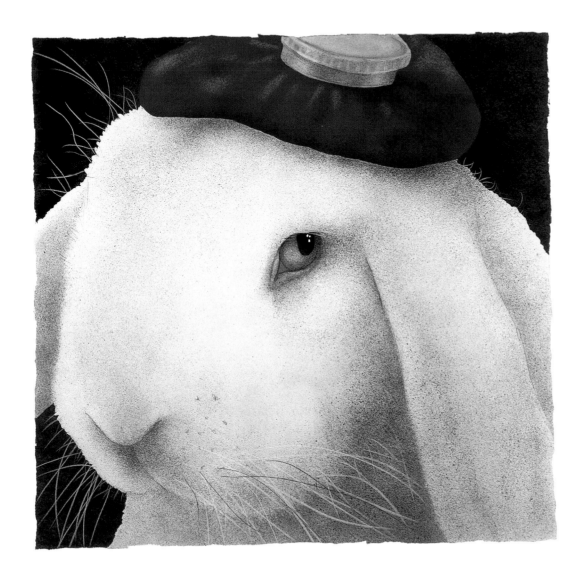

even my hare
hurts . . .

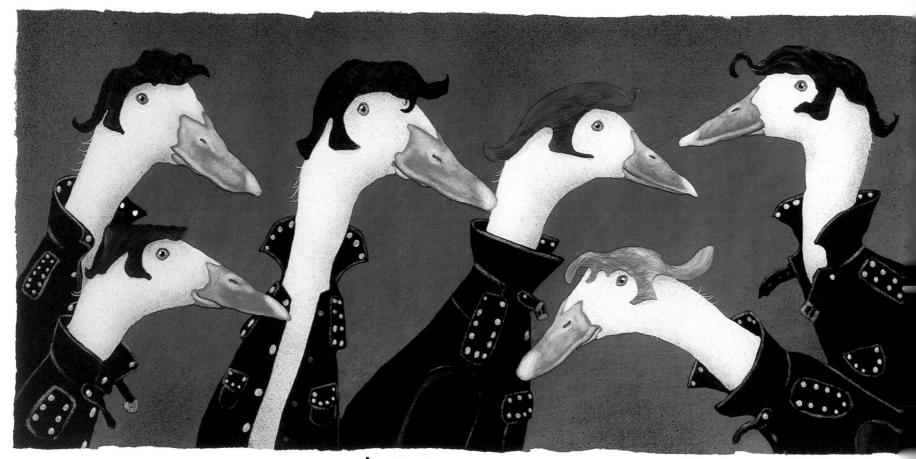

duck tails ...

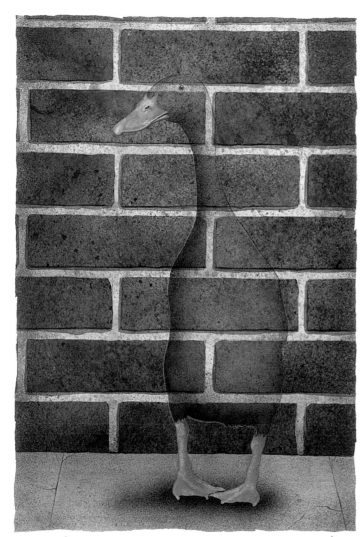

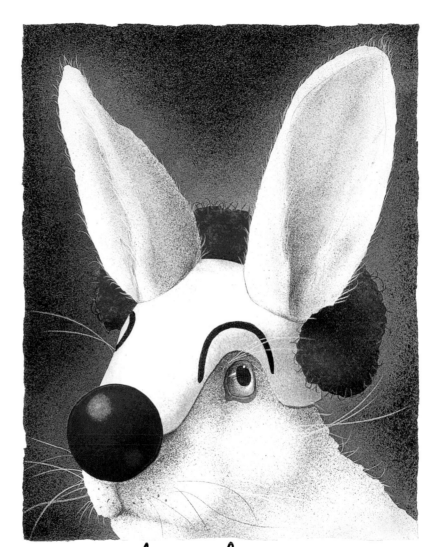

another brick in the wall ... funny bunny ...

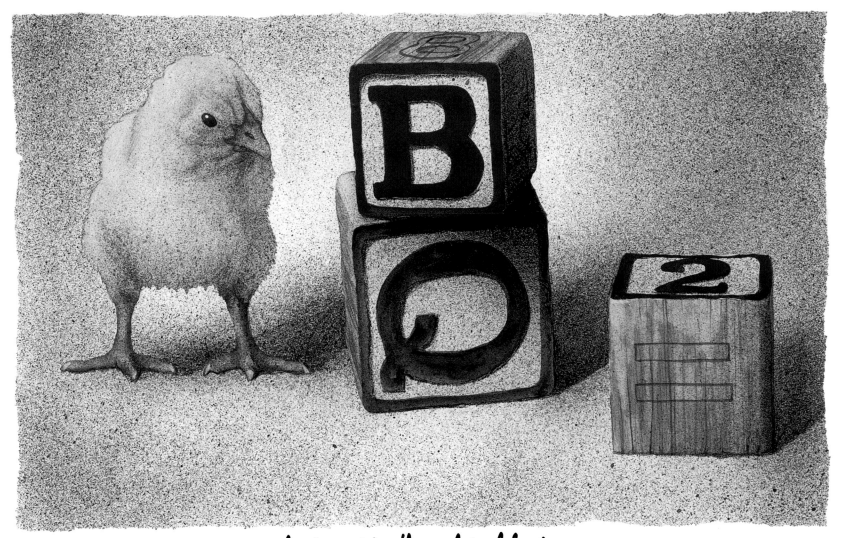

a chick off the old blocks ...

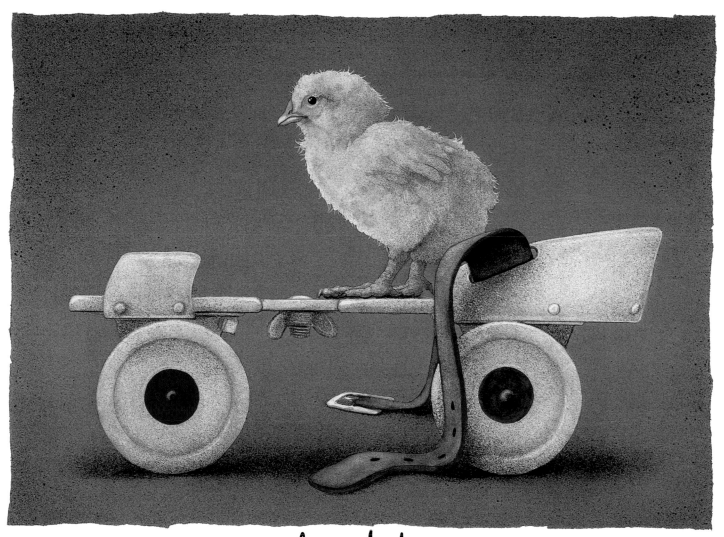

cheepskate . . .

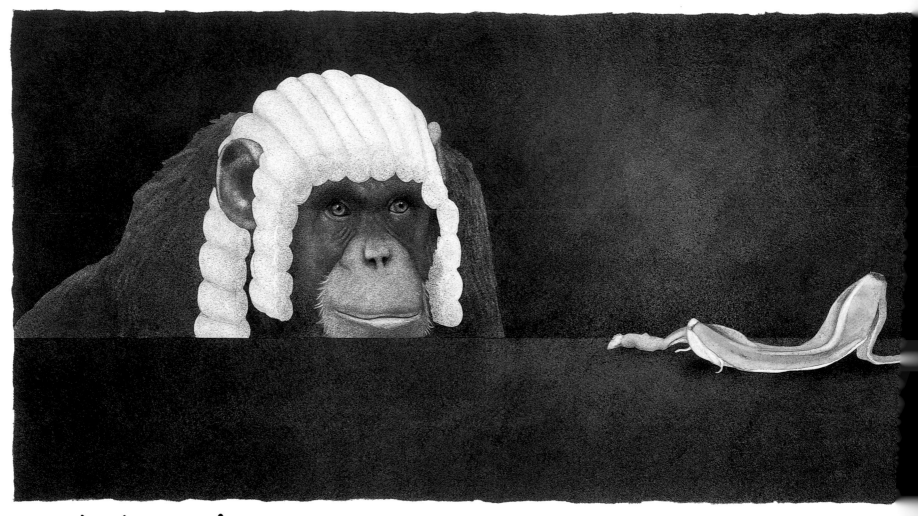

court of appeals ...

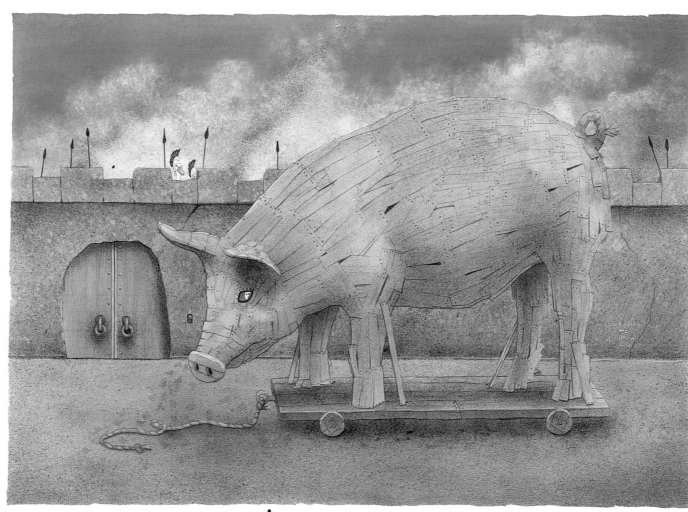

the Trojan pig . . .

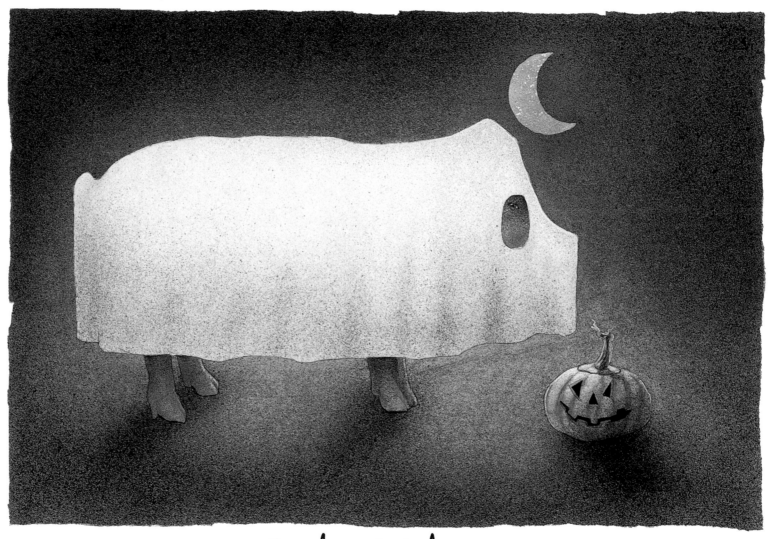

the haunted ham...

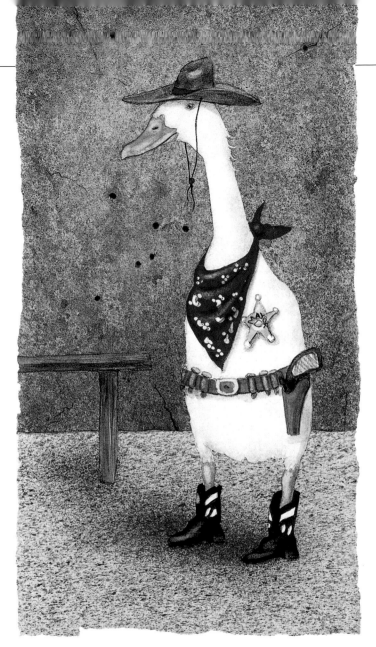

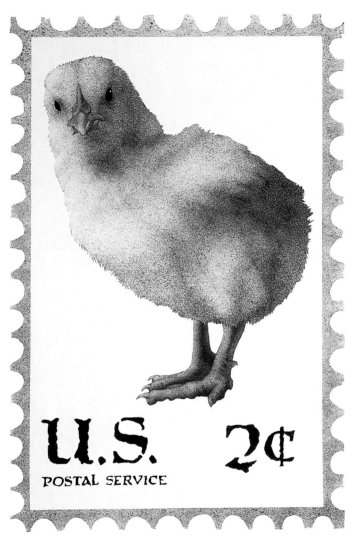

the chick's
in the
mail ...

The Carmel Kid ...

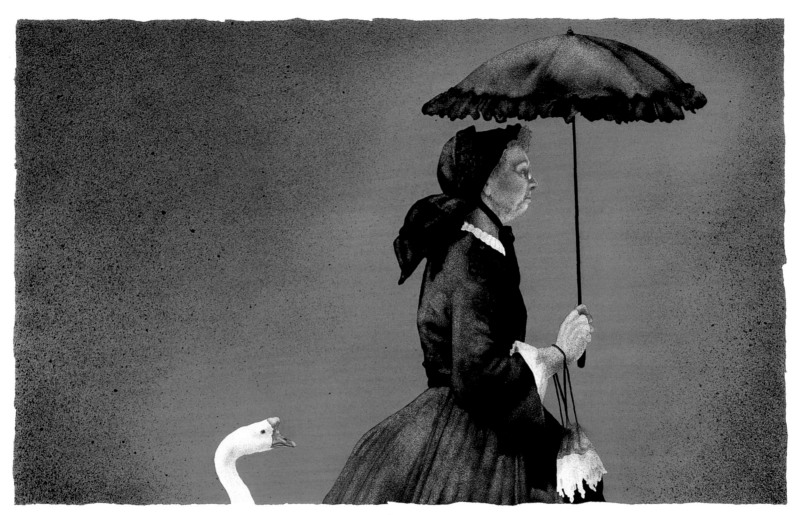

granny gets a goose . . .

Spotlight on sports...

Will Bullas takes the wide world of sports to a new place. Forget point spreads, earned run averages, bogies, strikes, sweeps and sets. Everything you can't imagine about sports is right here.

In Will's favorite pastime, there's a *Fowl Ball*, an owl (*Hoo's on First*), and lots of *Puppy Glove*. Elephants, of course, invented football on the wide-open field of the Serengeti, which is why we call it *The Big Game*. Frogs love watching golf and football but sometimes get a little too close to the action. Pigs love to race in anything with wheels. Apes don't care much for rules and cheat at tennis, which makes it hard for them to get a match going. Indian Runner ducks are highly intelligent and athletic, which has put them in the spotlight of boxing, diving and surfing. You also see them *Hangin' Around for the Holidays*, playing *Puck Duck* or stomping the competition on the *Swim Team*.

Maybe now you know Will well enough to imagine a winter scene with a couple of *Ski Bunnies*. He's in *A League of His Own*, and you can play, too.

hut
one ...

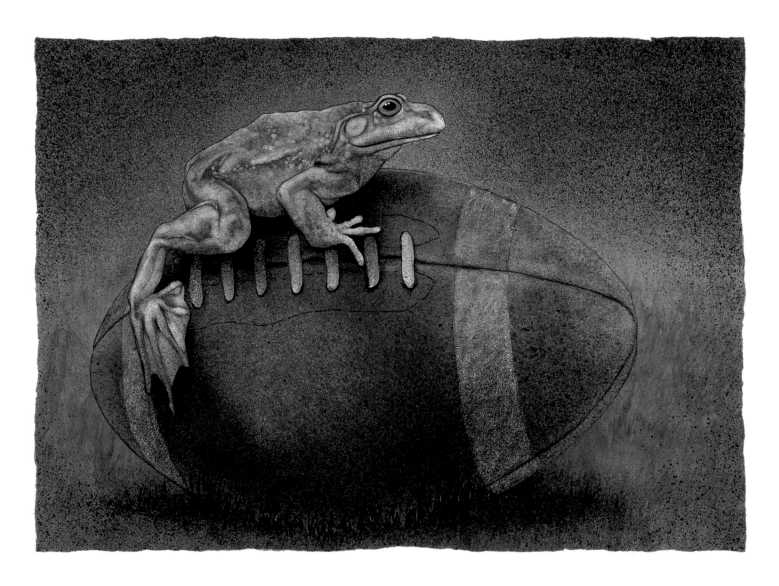

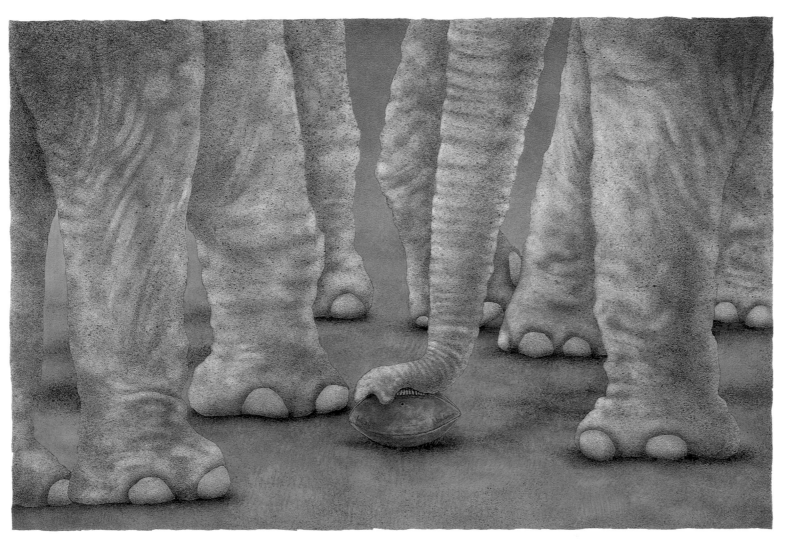

the big game...

the pool man...

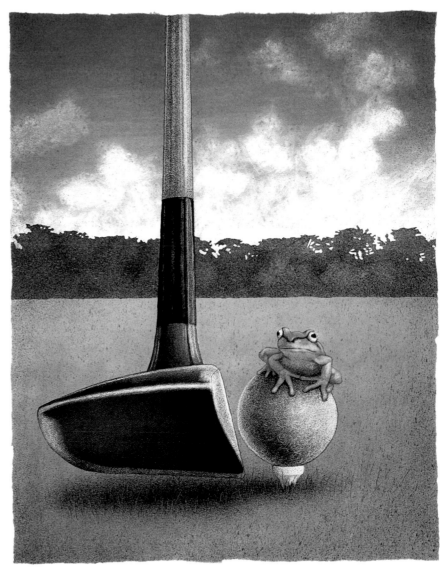

out of the woods...

swim team . . .

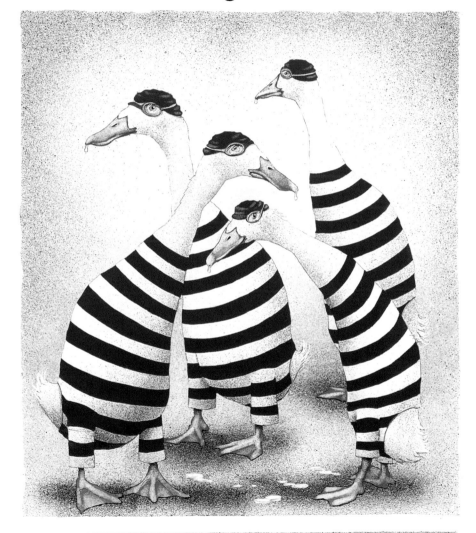

3 FT

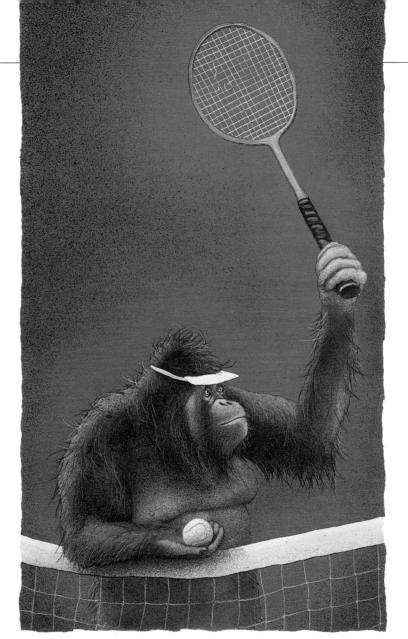

tennis anyone ?

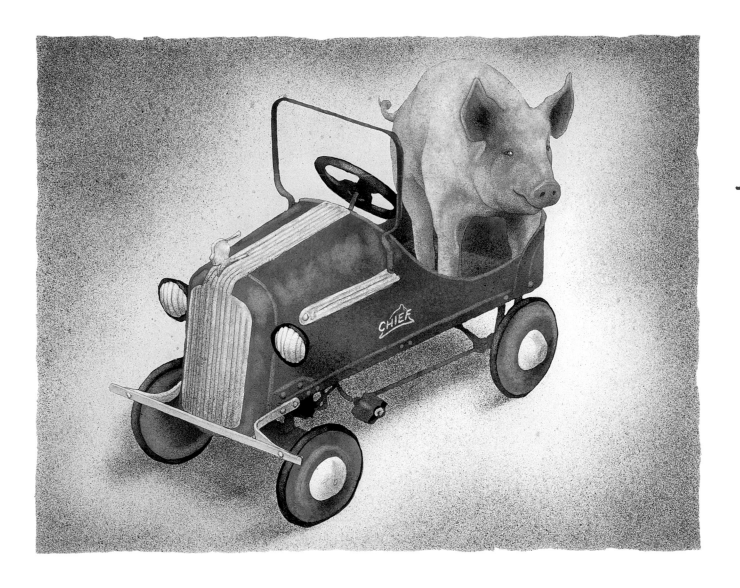

the road
hog...

fowl
ball ...

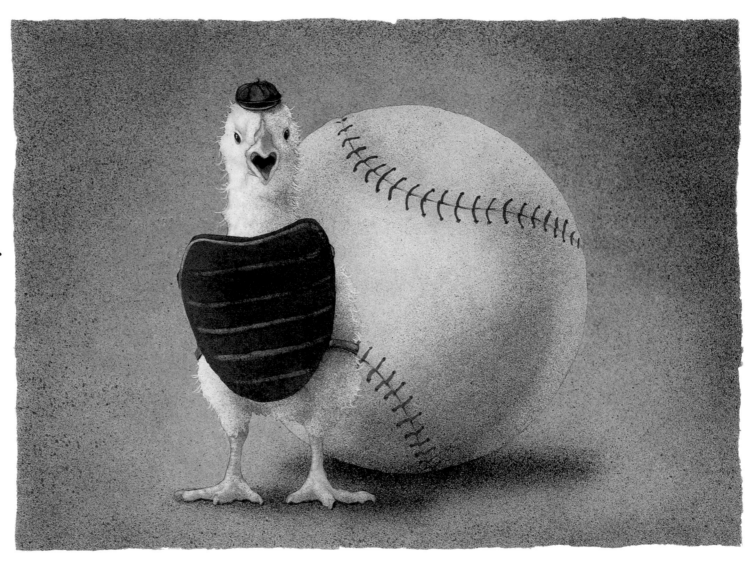

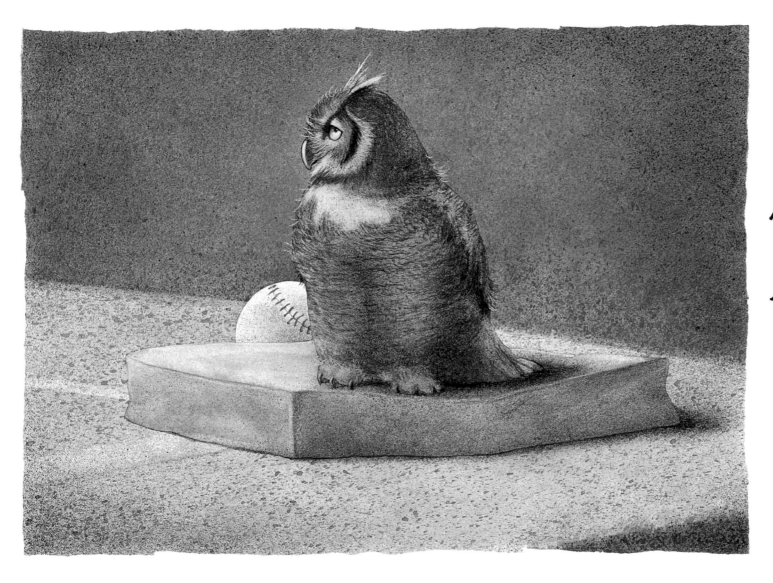

hoo's
on
first . . .

the
featherweight...

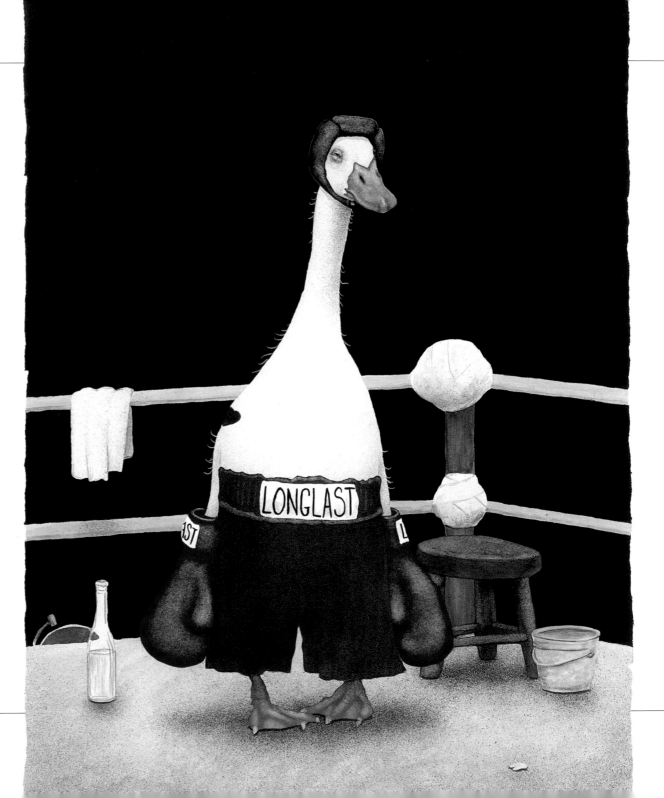

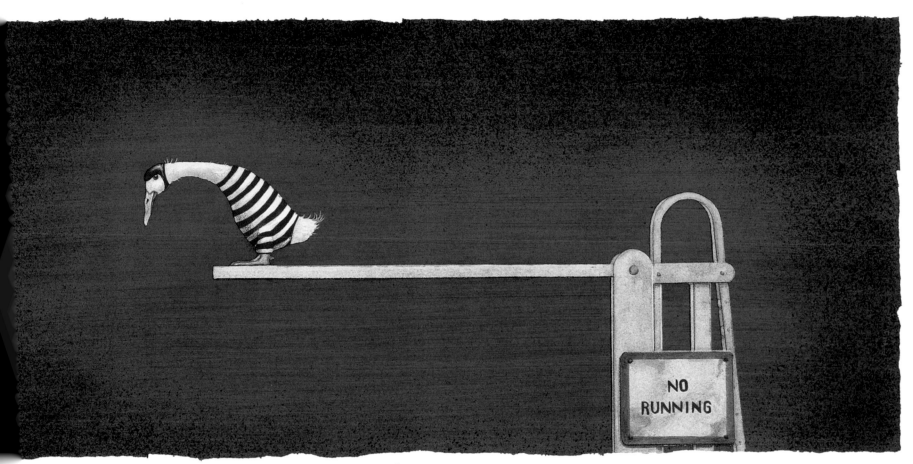

the diver . . .

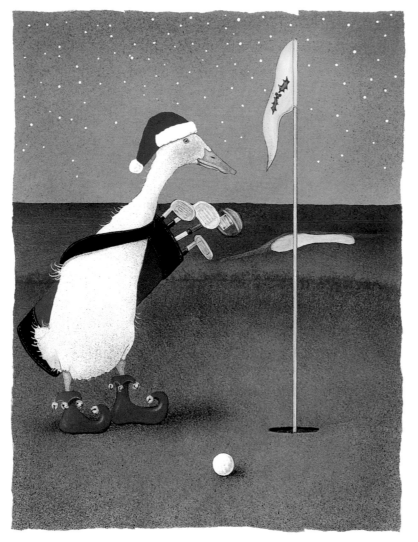

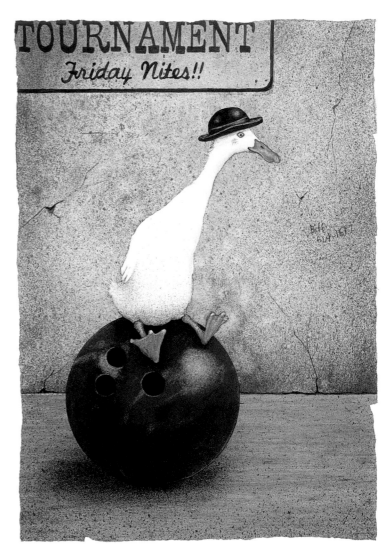

Santa's caddy... the bowler...

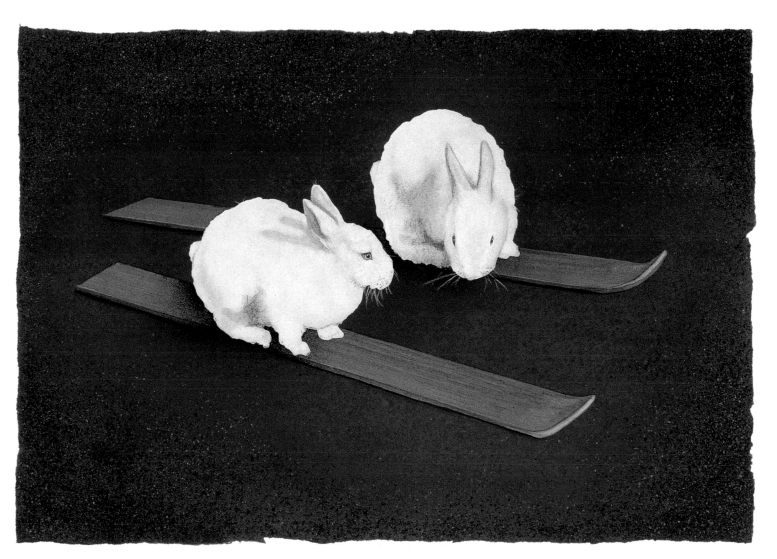

ski bunnies ...

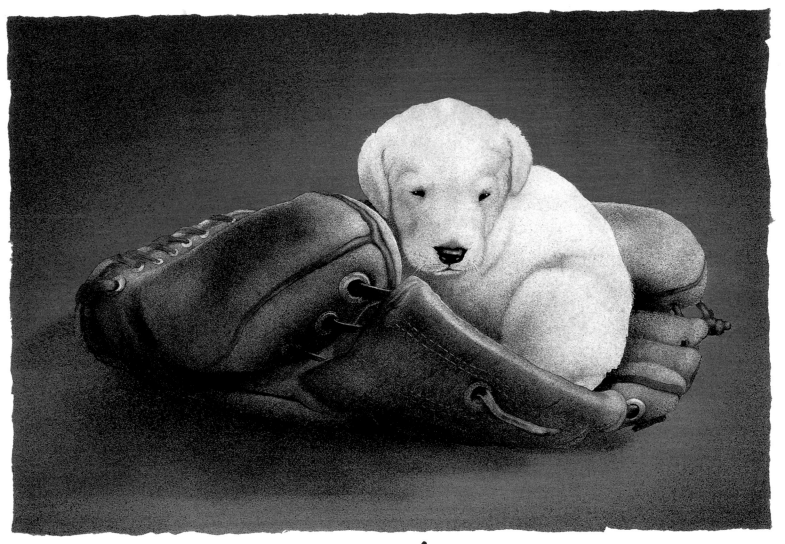

puppy glove...

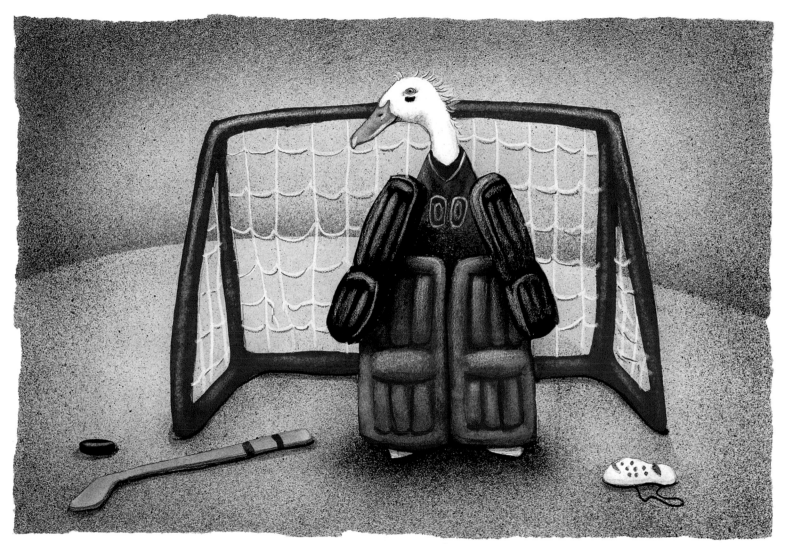

puck duck ...

the
chimp
shot...

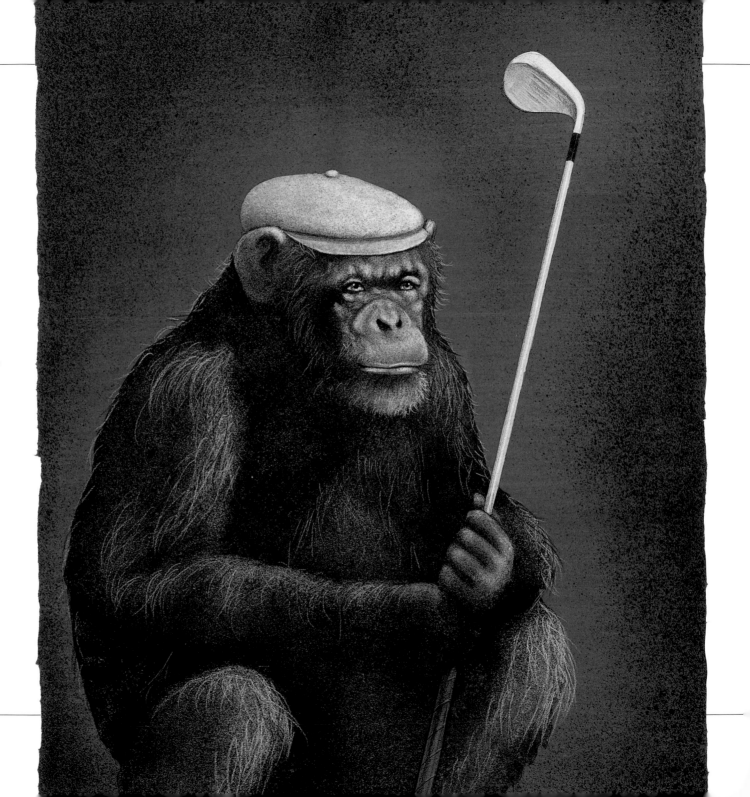

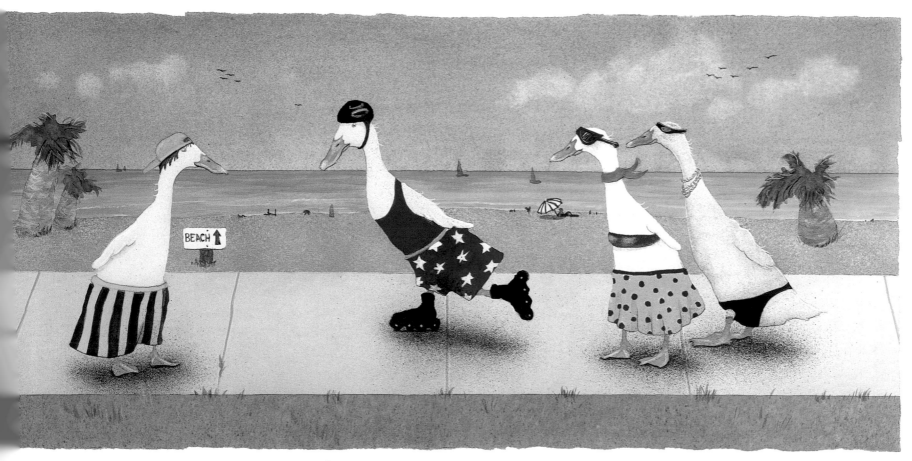

California stylin' . . .

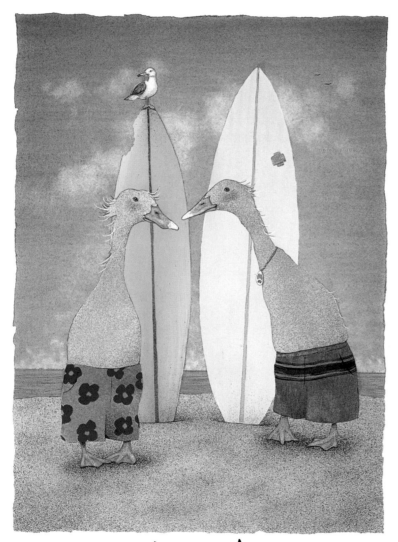

surf quacks..

hangin' around for the holidays ...

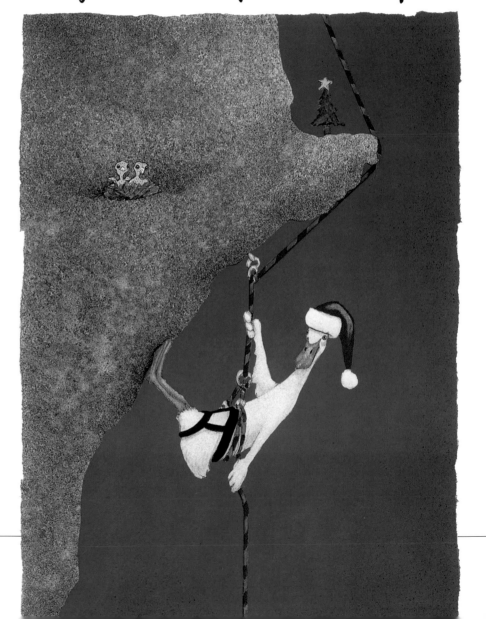

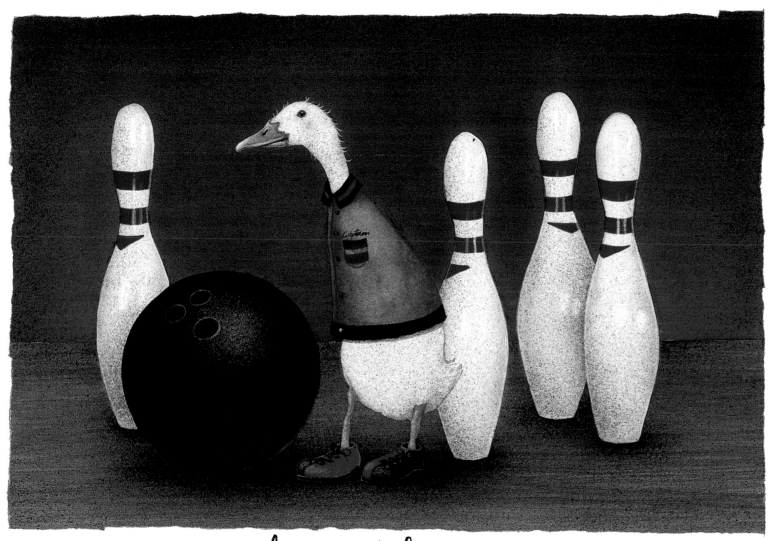

a league of his own...

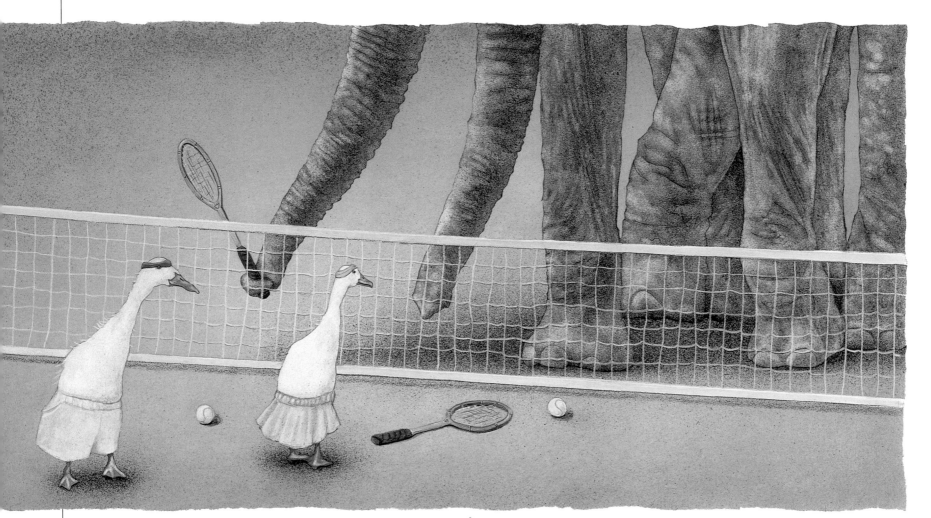

mixed doubles...

a duck for all seasons...

Will Bullas wants to know, is it we humans who have animal characteristics, or do the animals have human ones? He's looking over our shoulders, from the mating game to the golf course, and he has a clue. The animal kingdom has an unlimited supply of material for his human humor, especially the self-revealing variety. And of all the creatures he paints, Will's favorite is his alter ego, the Indian Runner duck.

Until now, ducks were confined to ponds and postage stamps. No longer. Will Bullas paints ducks with *vision*. Creative ducks. Ducks with goals. Ducks who can get it for you wholesale. "I have studied, enjoyed and painted so many Indian Runner ducks," he says, "that there isn't a place or predicament I don't think they can't improve."

Becoming *The Ductor* is very practical and admired by many—what mama doesn't want her child to marry one? But sometimes it's the duck from the wrong side of the tracks who steals a girl's heart at the *Sock Hop*. And why do we think a fake pair of glasses, a big nose and a mustache make a *Secret Agent* disguise?

That's how it is with Will's Indian Runner ducks, who cheerfully remind us that no matter who we *think* we are, we're all ducks...in the same soup.

campfire
ghost
stories ...

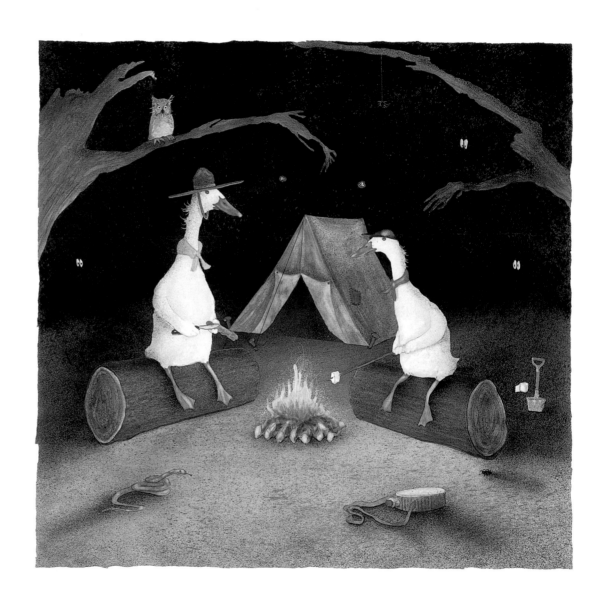

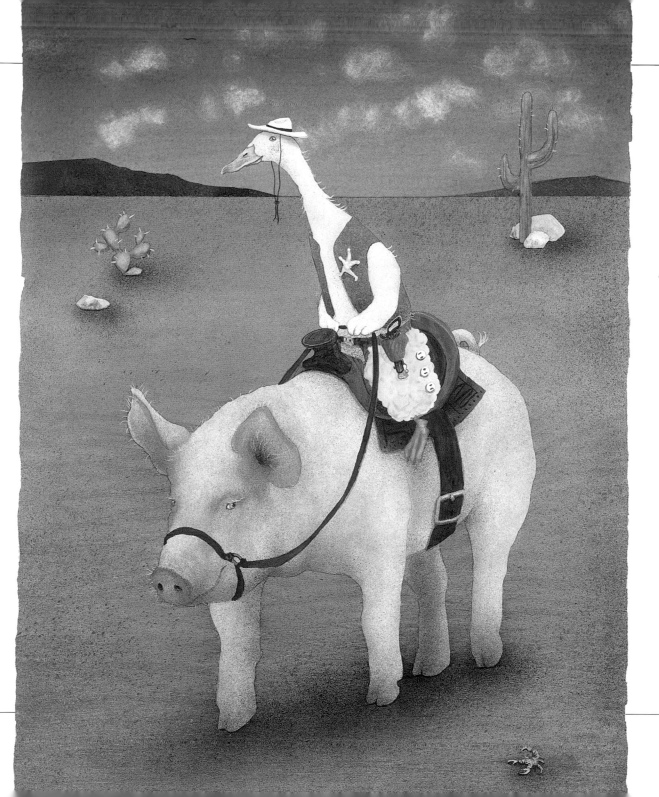

There's a new
sheriff in
town...

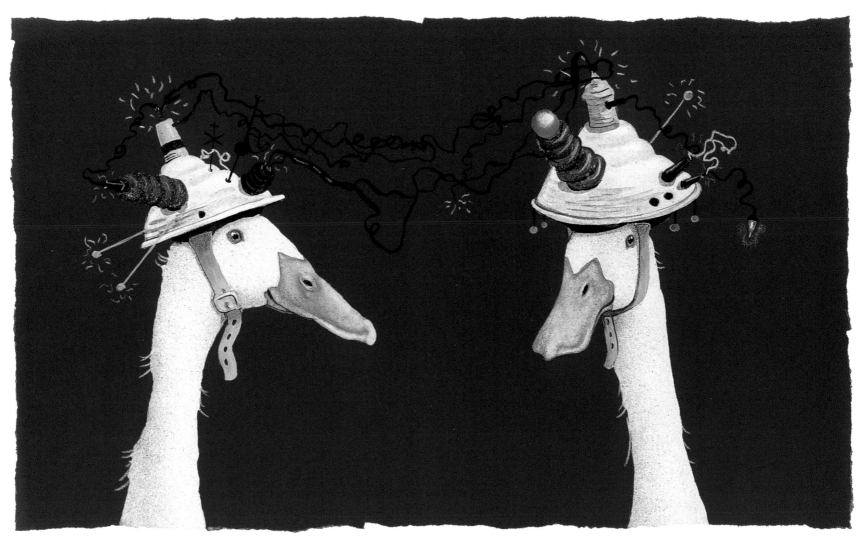

a meeting of the minds...

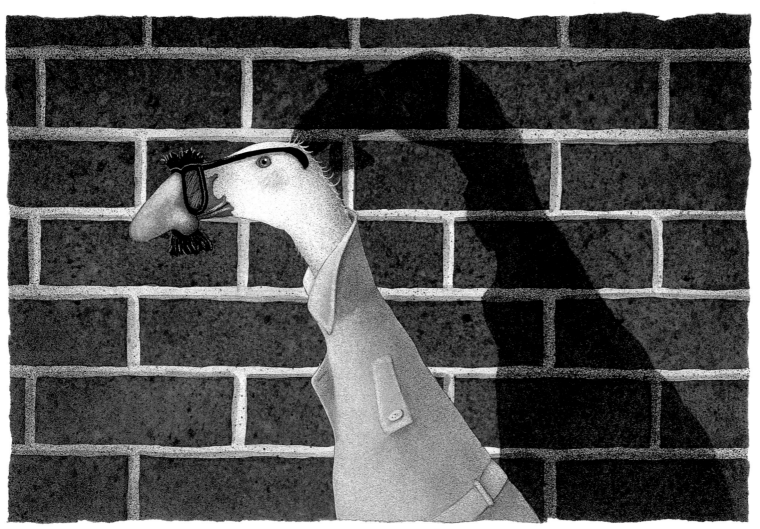

secret agent . . .

a lonely
heart
just like
Pagliacci...

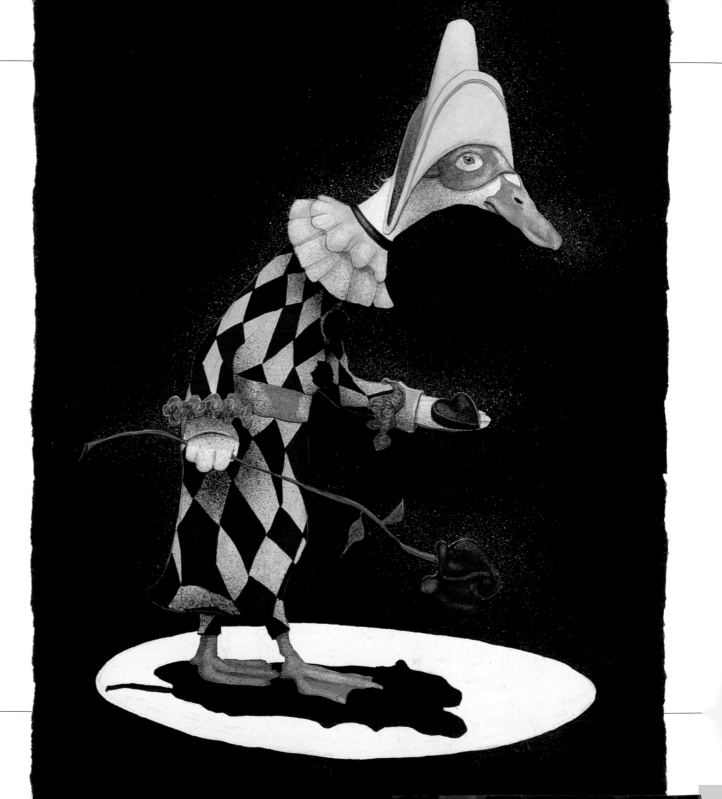

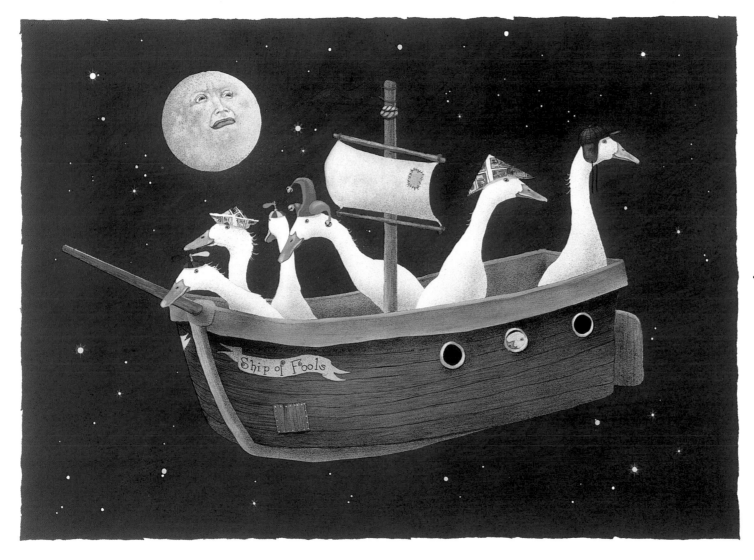

ship
of
fools ...

the grand
finale ...

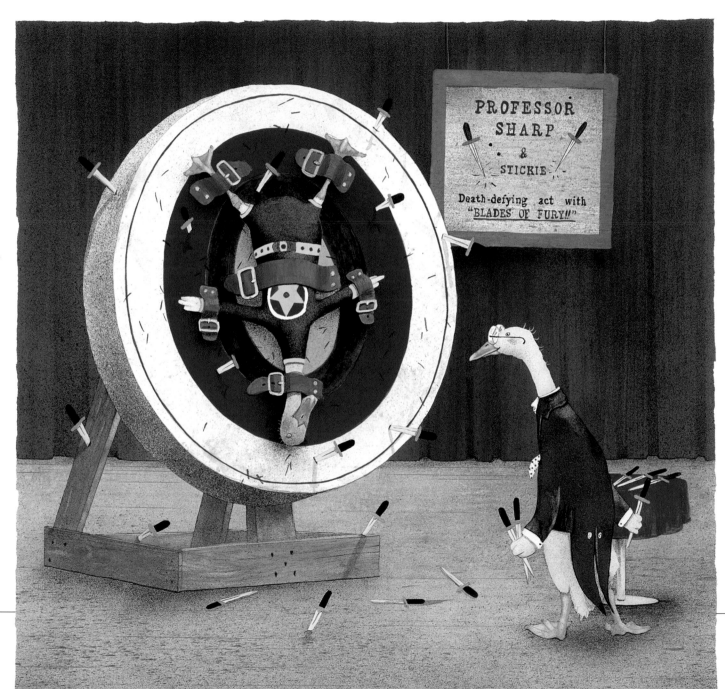

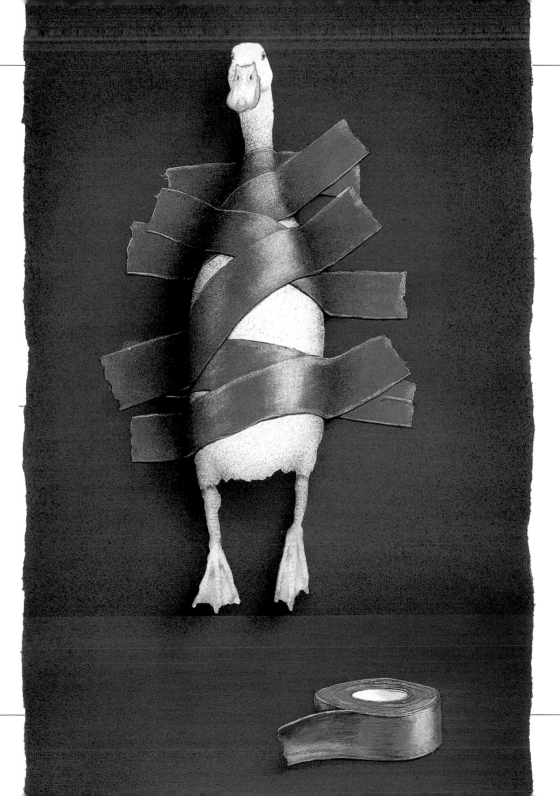

duck tape ...

sock
hop...

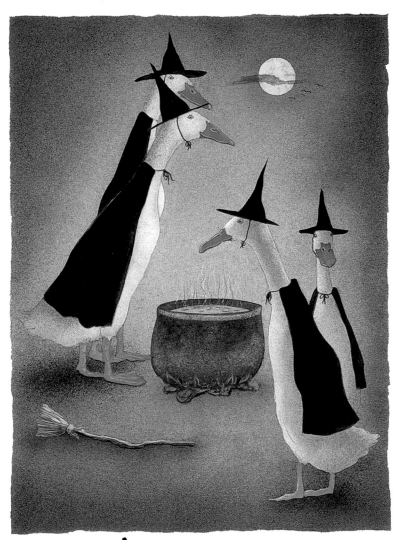

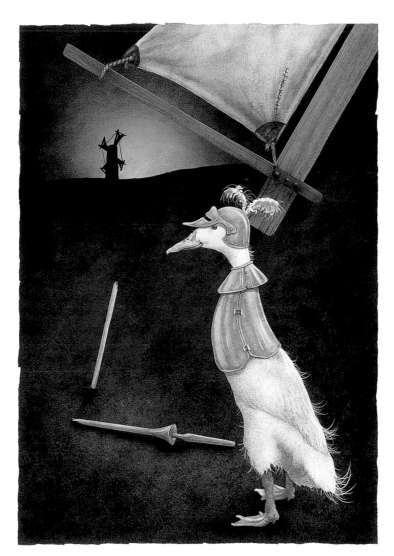

hocus pocus ... Don Quixote ...

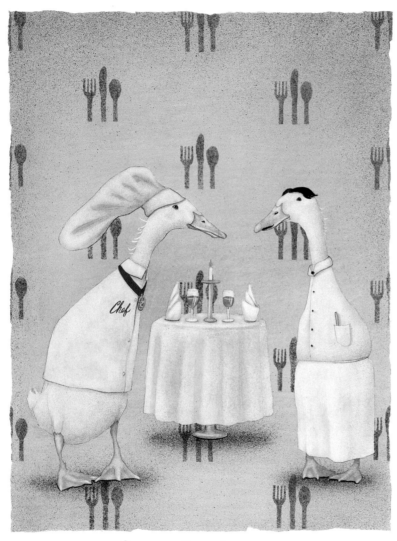

le bistro …

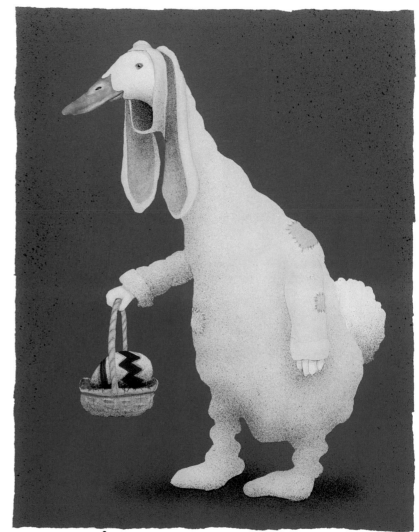

the Easter bunny …

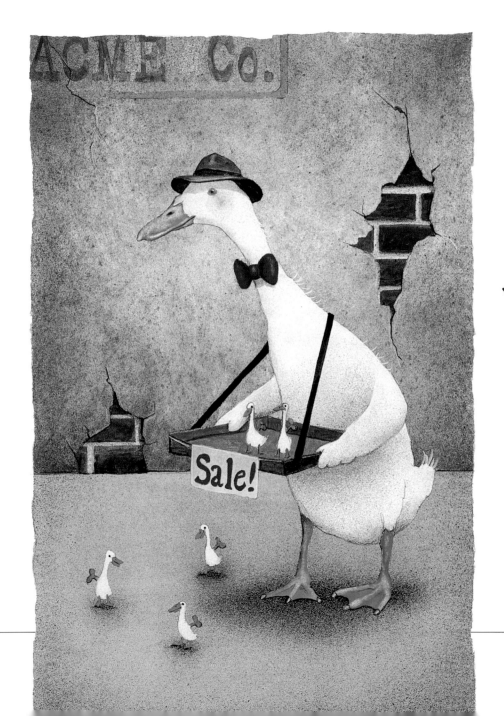

the vendor ...
I can get it for you
wholesale ...

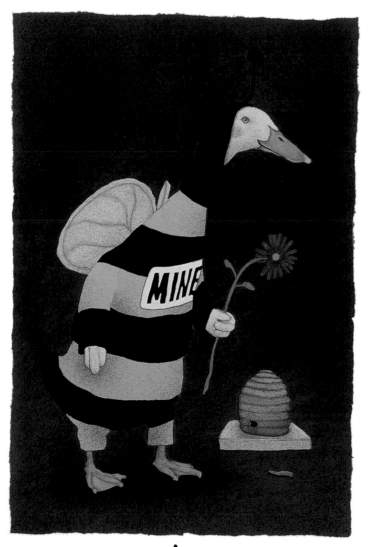

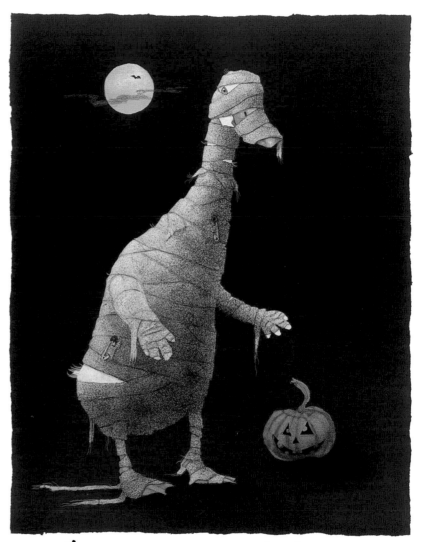

please bee mine . . .

the mummy strikes . . .

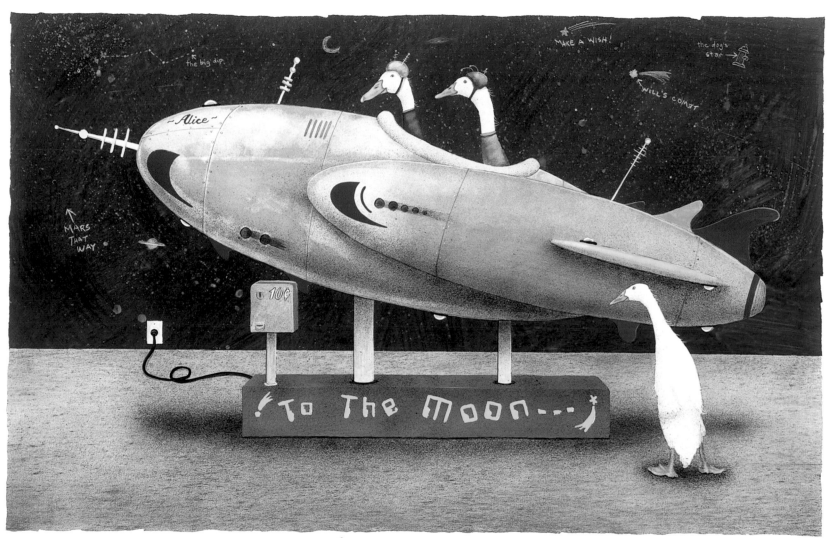

the rocketeers ...

the ductor …

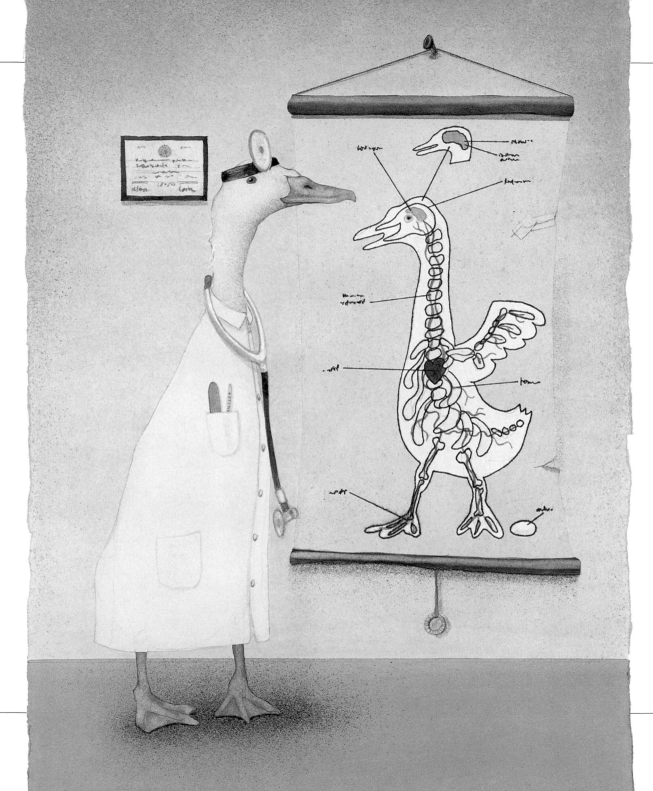

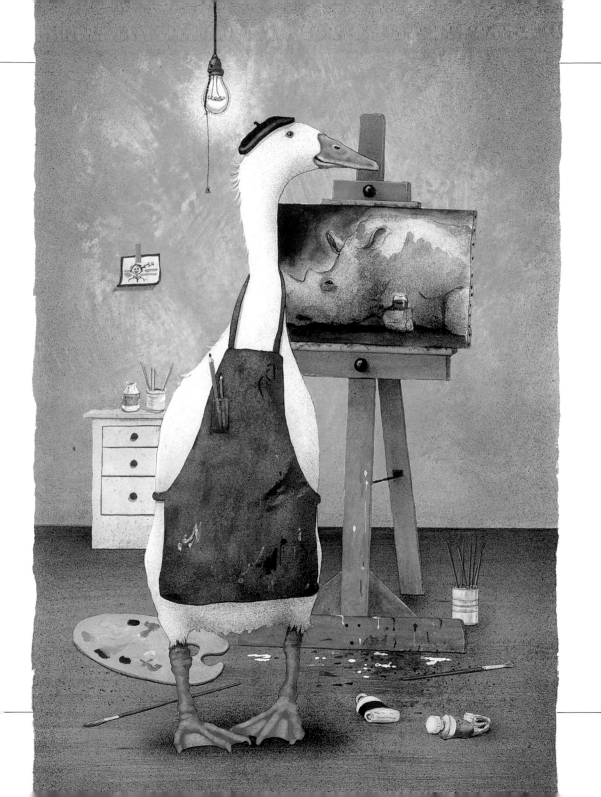

the artist...

Supermom...

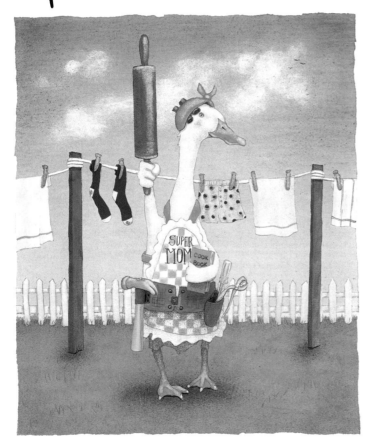

the tooth faerie....

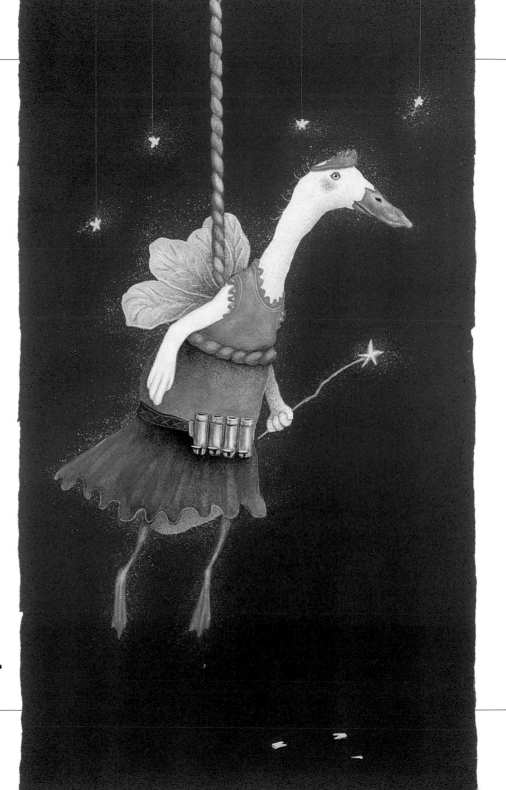

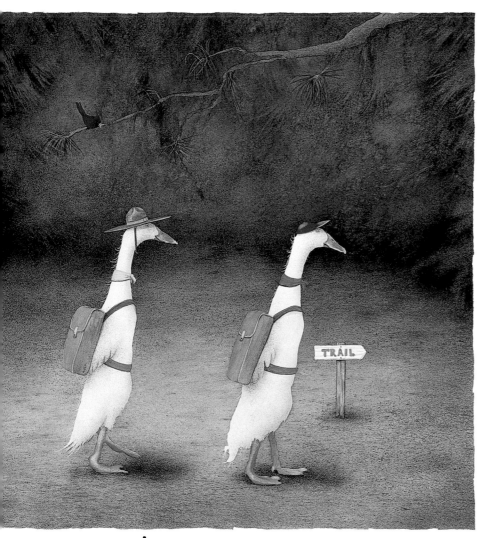

back quackers...

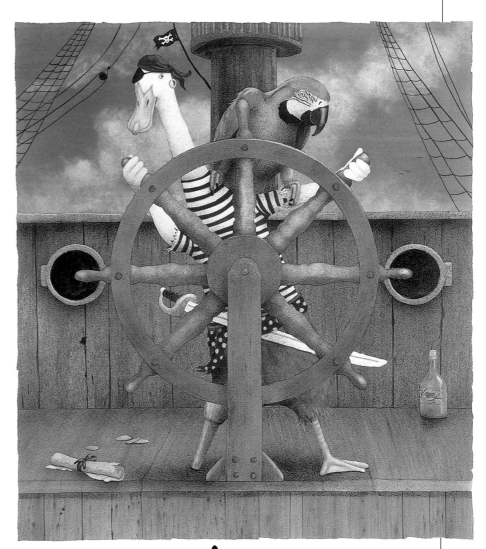

ahoy...

Space
Cadet...

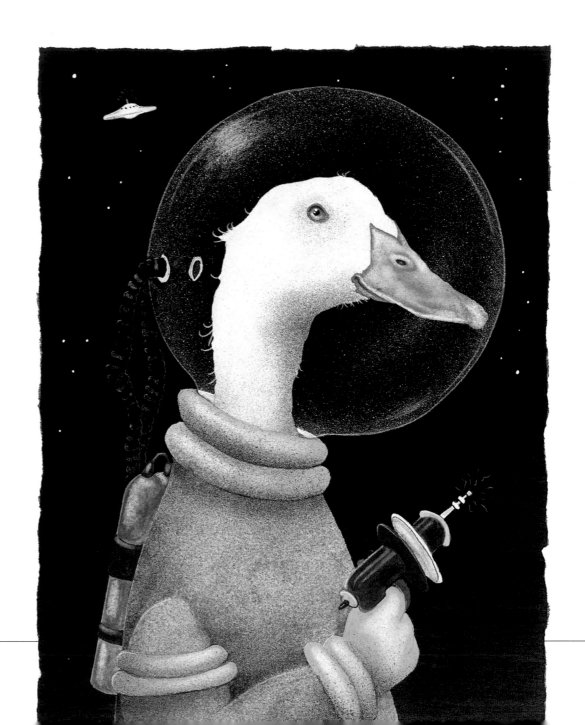

It's a jungle out there ...

We can't all be *Lord of the Jungle*. Most of us aren't a *Rocket Scientist*, either. Sure, there's *Higher Learning*, but that's not going to make you *Mr. Hip*. Okay, so you work your way up to *Storkbroker*, then find yourself getting into a little *Monkey Business*. That's when you realize that it's still a jungle out there and you'd better find yourself a *Legal Eagle*. A court case with a *Big Talker* is more fun than a *Dog Byte*. Sort of.

Still, there's always Friday night to look forward to—sharing a glass of wine with some turkey you met last week or taking your favorite little duck to *The Drive-In*. Of course, the real *Party Animal* is waiting for the holidays, when even *The Censors* can stand under the *Mistletoad* and steal a kiss. But beware of paws *Bearing Gifts*.

In Will Bullas' art, anything could happen. And it doesn't matter if you are *Lord of the Jungle*—somebody's still going to give you a tie for *Father's Day*.

do zebras
dream in
color?

the censors ...

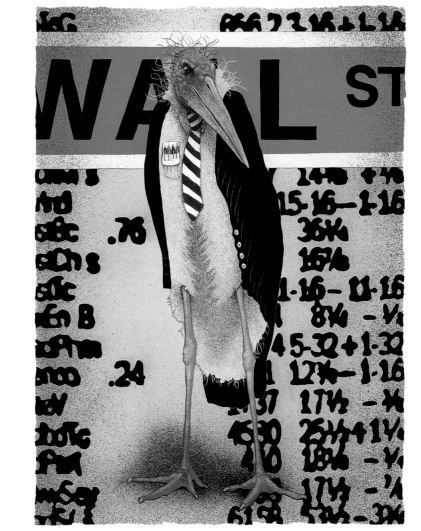

the storkbroker...

irrelevant...

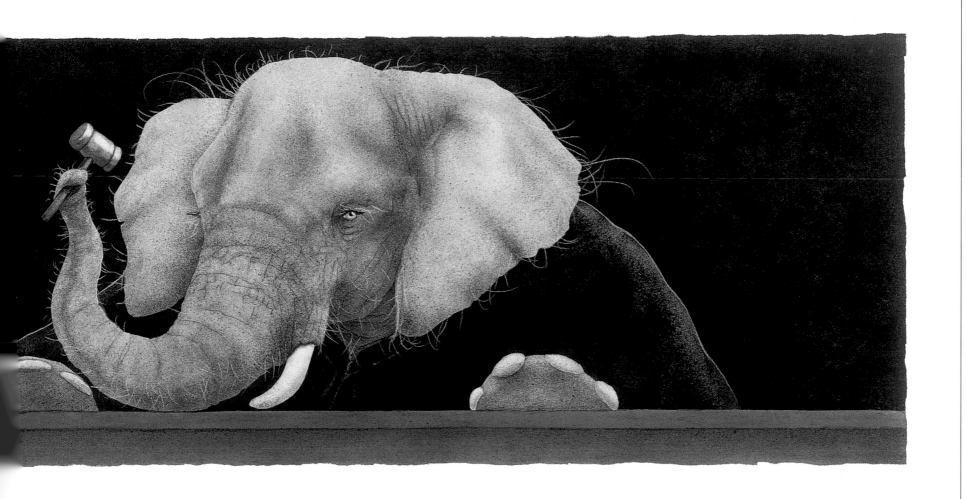

higher learning . . .

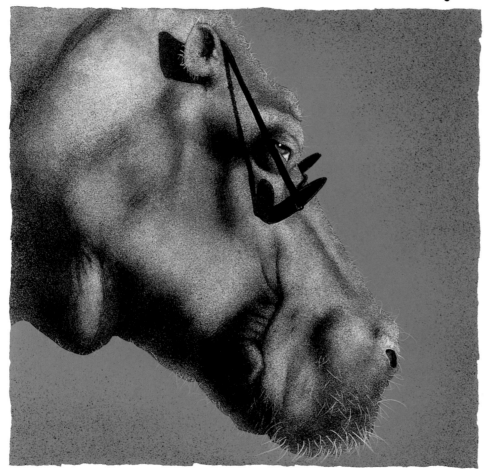

Mr. Hip . . .

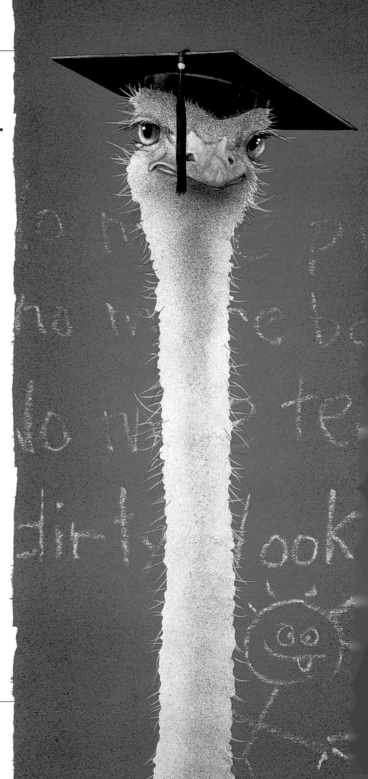

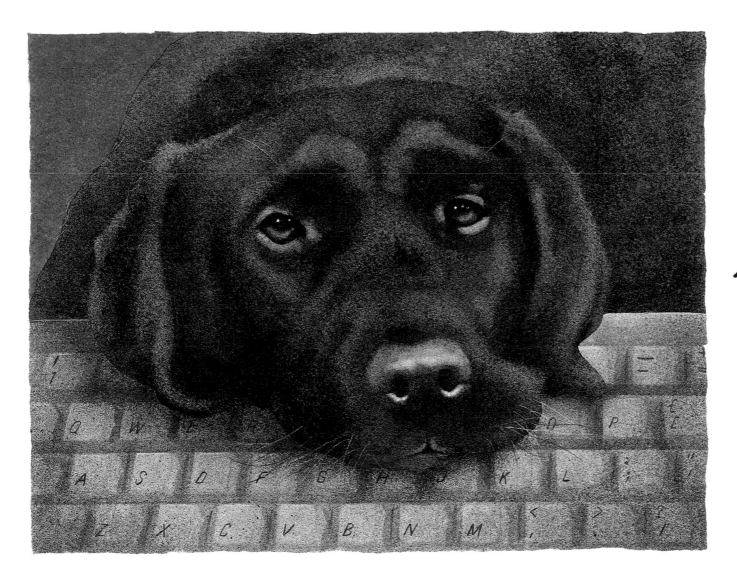

dog
byte ...

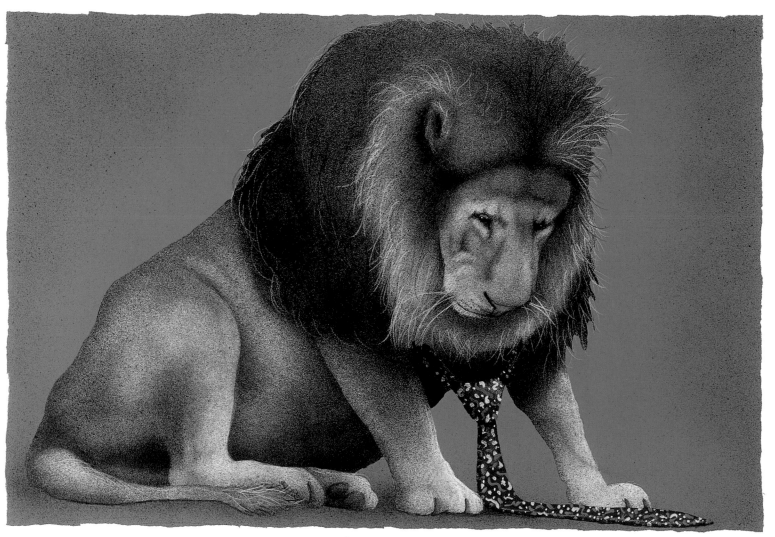

Father's day...

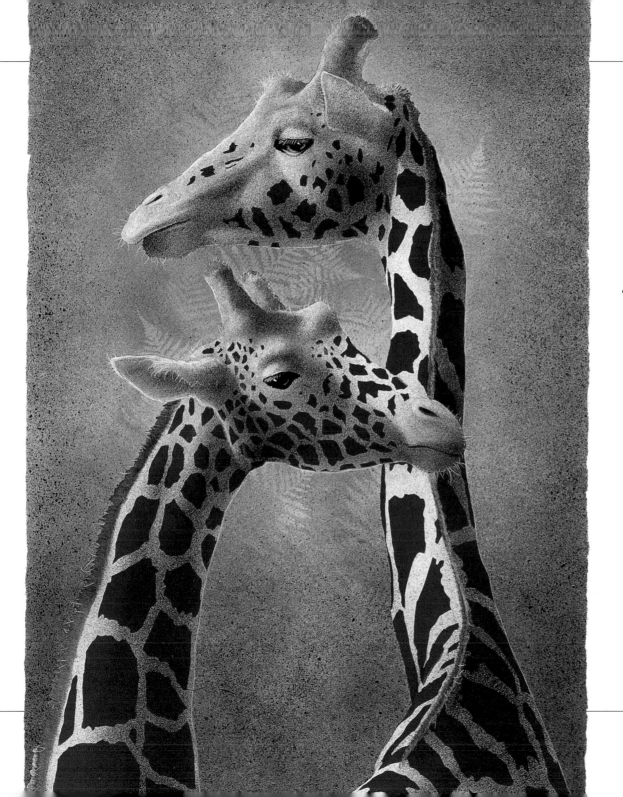

neck and
neck…

the consultant...

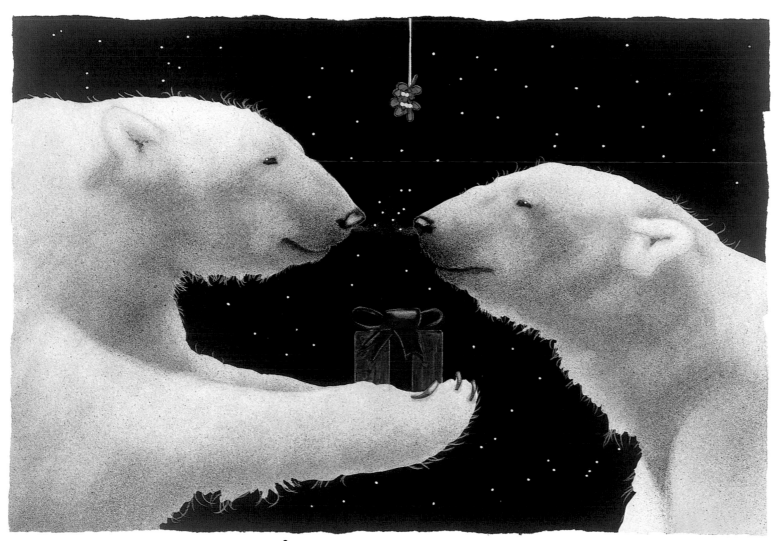

bearing gifts...

the rocket
scientist ...

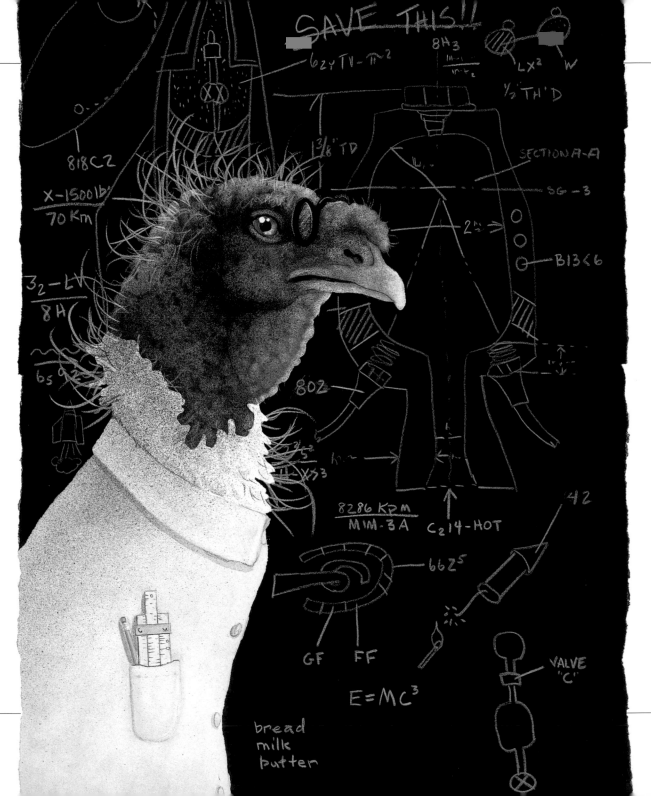

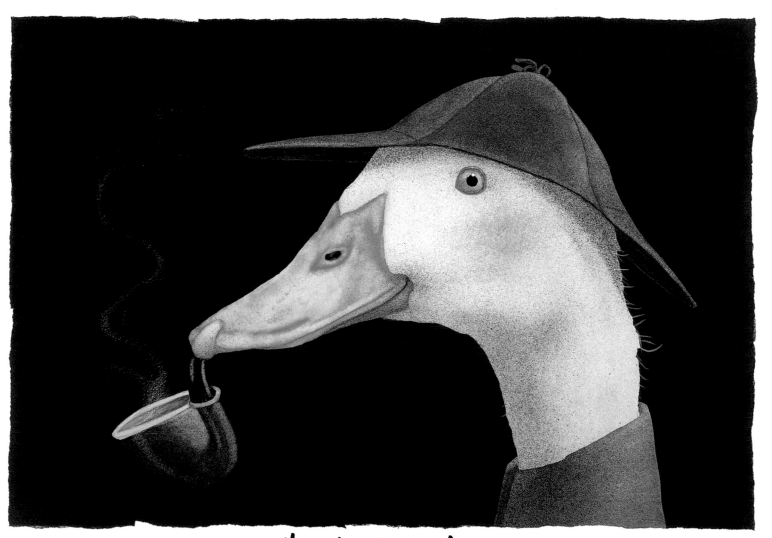

the Holme boy...

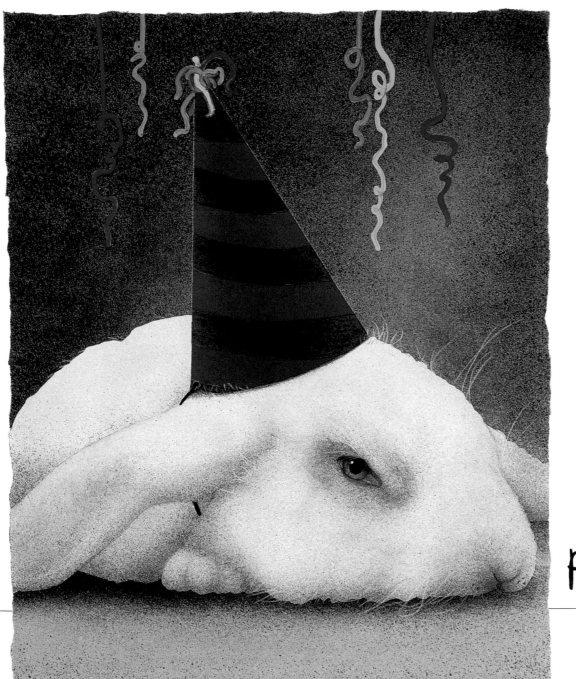

party animal . . .

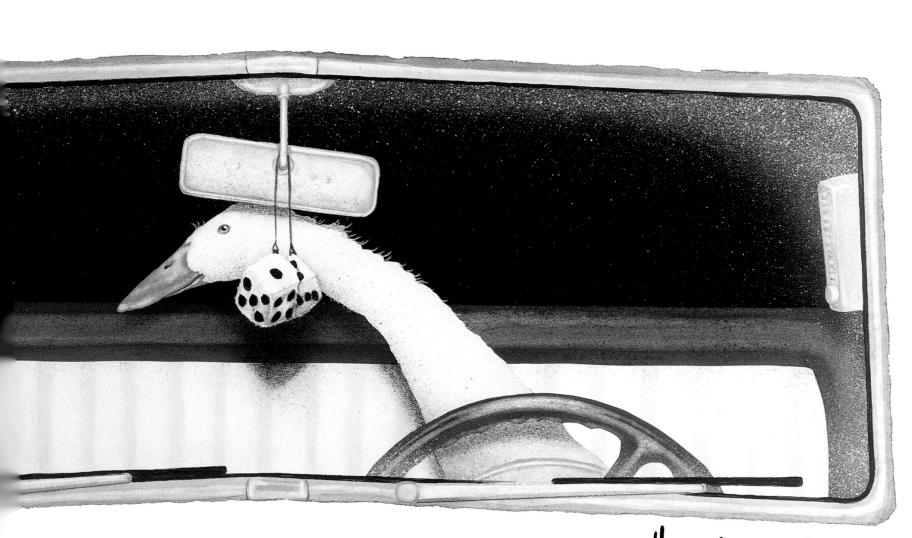

the drive-in ...

teacher's
pet ...

I will never forget!

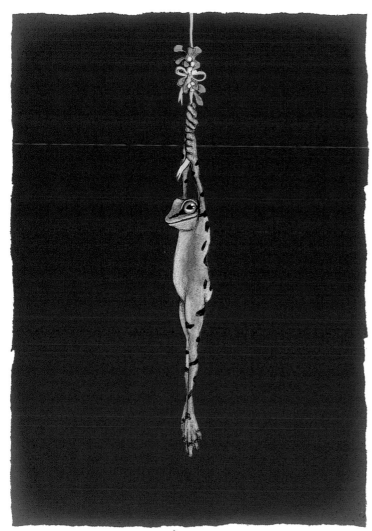

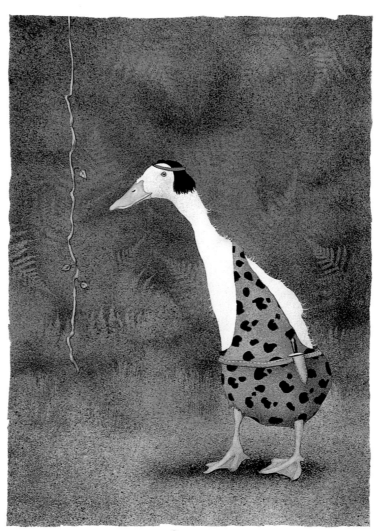

mistletoad... lord of the jungle...

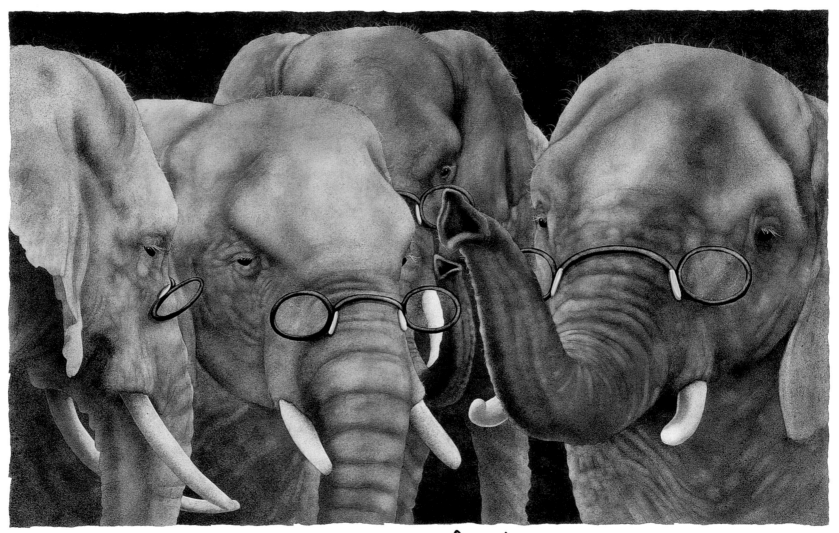

seen and herd...

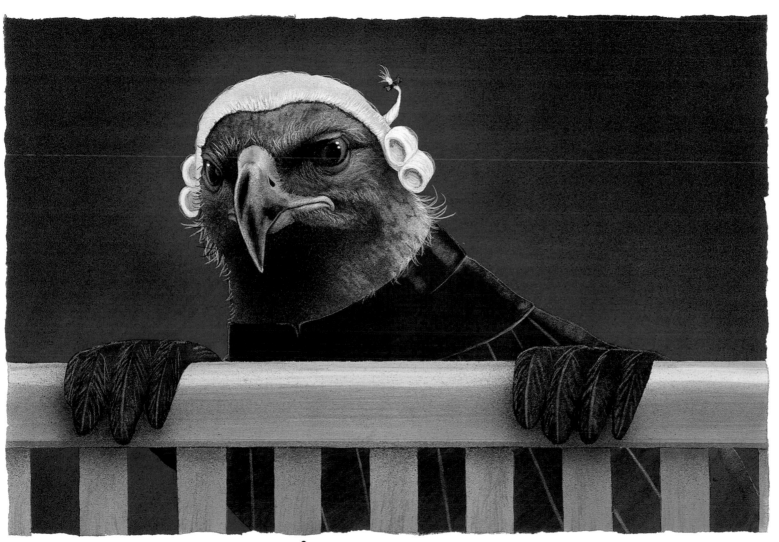

legal eagle ...

monkey
business ...

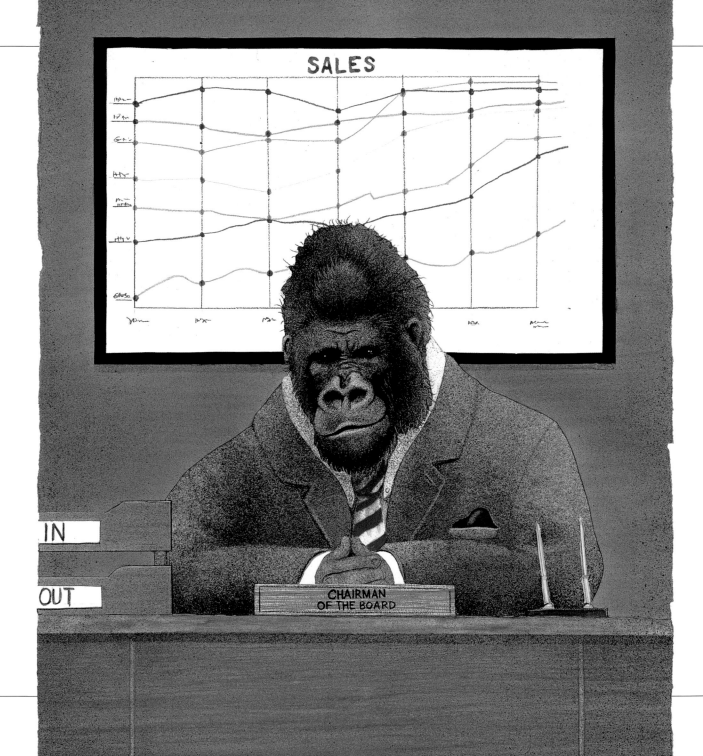

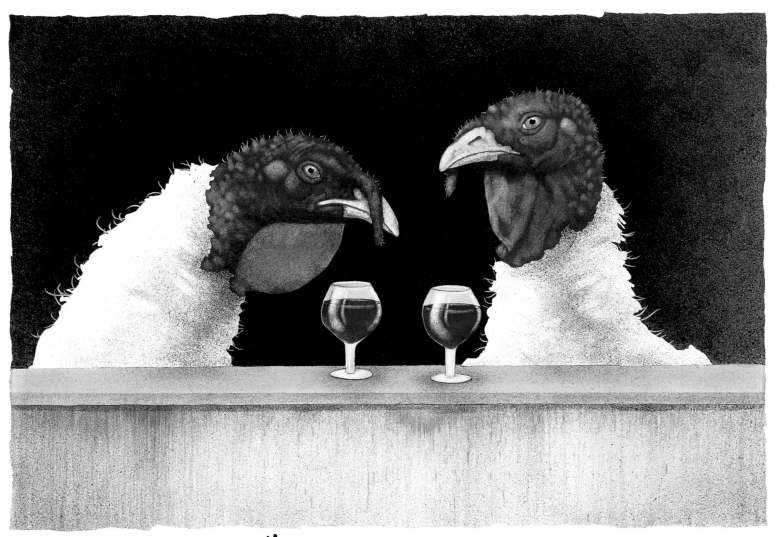

the wine goblets . . .

big
talker...

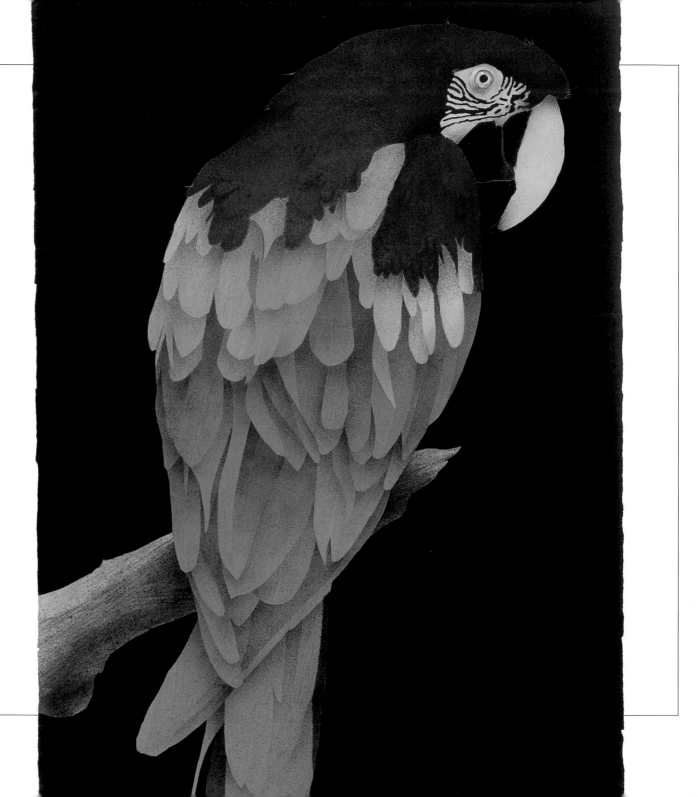

The serious side of Will Bullas

Will Bullas' deep appreciation for, and curiosity about, the world and its mysteries are as wide-ranging as his humor is irrepressible. Two themes reappear throughout the body of his more serious work: the Old West and the Far East. His interest in the West spans the romance of the cowboy myths and the quiet power of the Native American. A favorite piece is *Anything for Billy*, a portrait of Will's son.

Traveling halfway around the world when he was drafted to serve in Vietnam, Will discovered, amid the struggle of war, the extraordinary beauty of the land and the people of Asia. His tigers and warriors reflect his mystic impressions of the East.

In addition to creating characters from his collection of masks, makeup and costumes, Will uses himself, friends and family as models. In this section, film industry sculptor Wah Chang appears as *The Magician*. Will's self-portrait, *Fool's Time*, was selected by the National Academy of Design for the 1996 exhibition, and *Women's Day* was in their 1998 show.

Wherever Will Bullas' imagination takes him, be it humorous or serious, the result is pure magic.

anything for Billy . . .

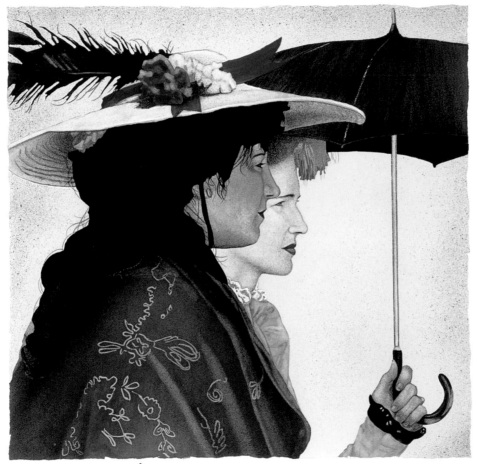

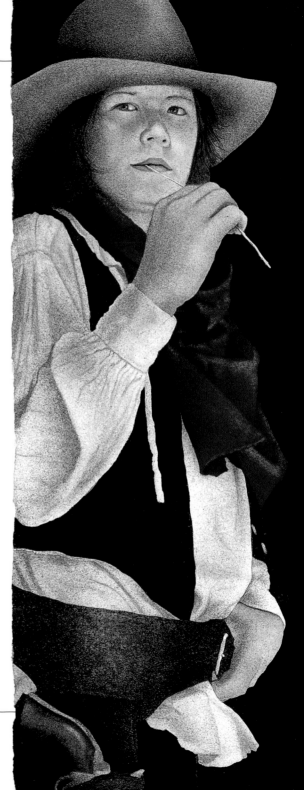

women's day . . .

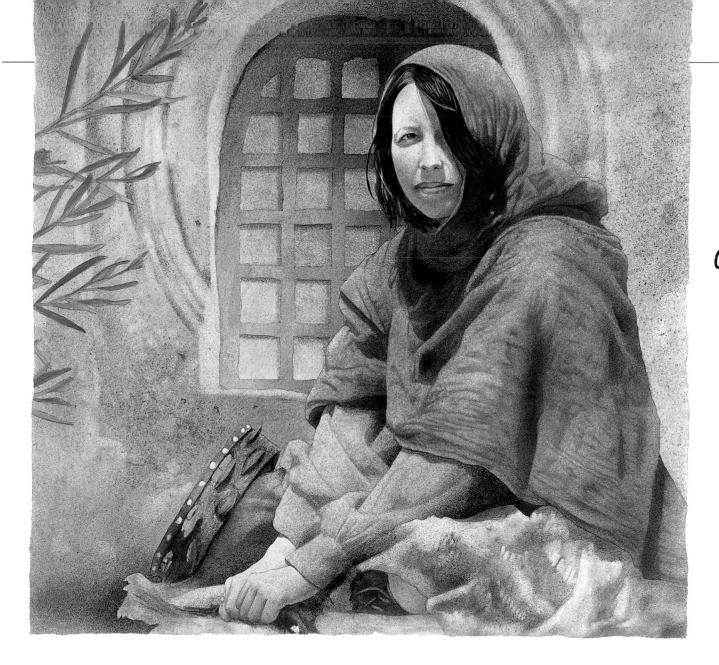

gypsy...

the year of the dog ...

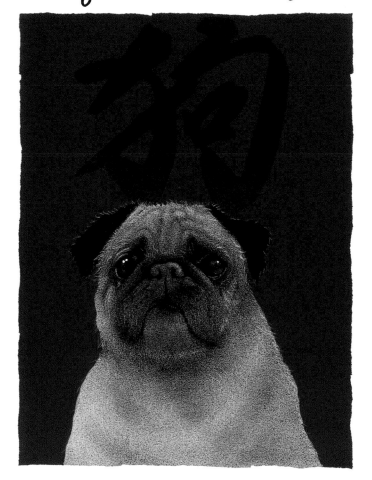

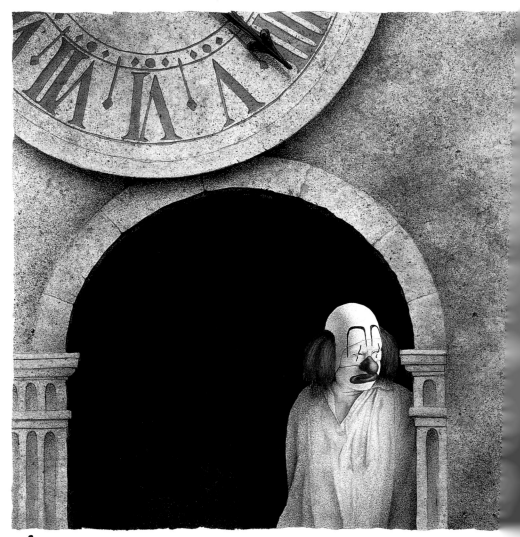

fool's time ...

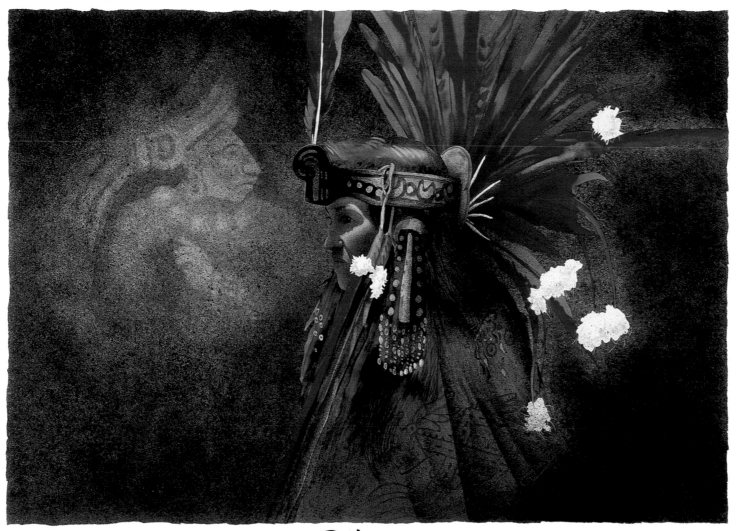

Maya...

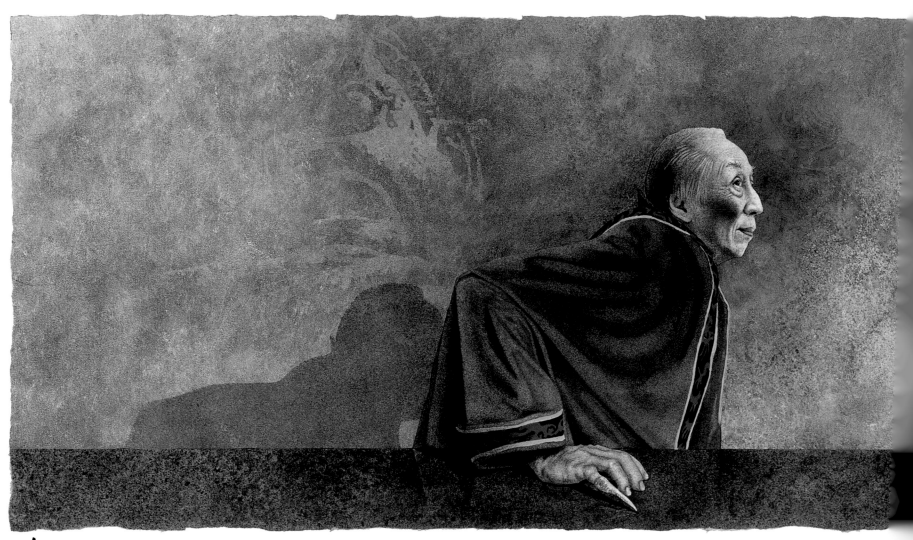

the magician...

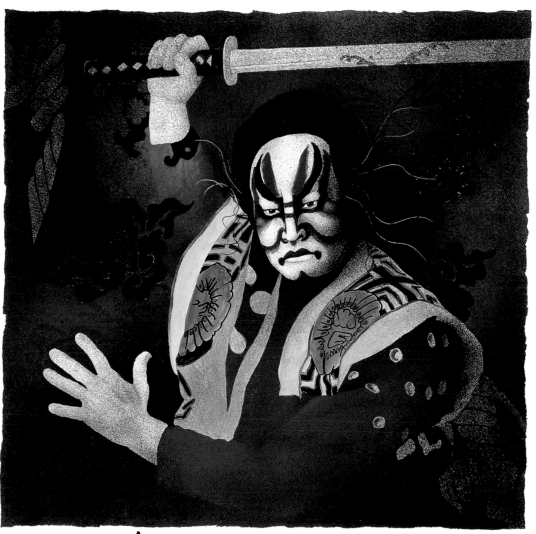

the dream warrior...

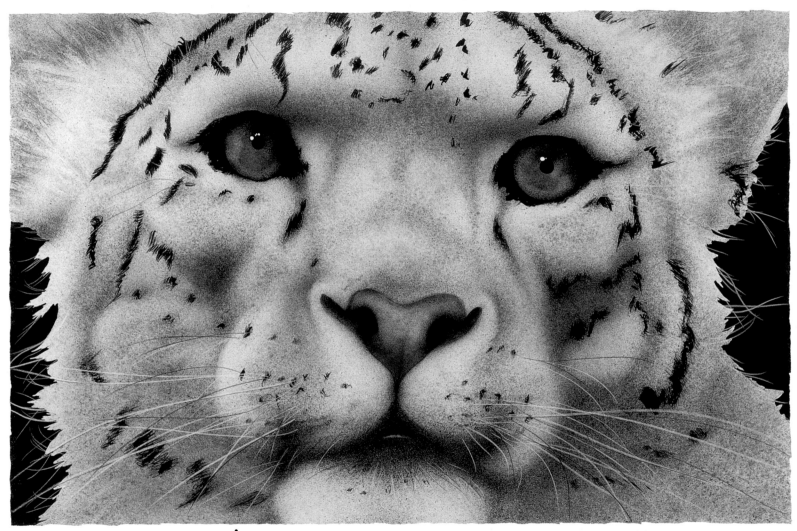

the emperor of Everest...